GLYN DEWIS
THE PHOTOSHOP TOOLBOX

Essential Techniques for Mastering Layer Masks, Brushes, and Blend Modes

rockynook

THE PHOTOSHOP TOOLBOX

Glyn Dewis

www.glyndewis.com

Editor: Jocelyn Howell
Project manager: Lisa Brazieal
Marketing coordinator: Mercedes Murray
Interior design, layout, and type: WolfsonDesign
Cover graphics and interior graphics: Dave Clayton
Cover design: Dave Clayton

ISBN: 978-1-68198-395-0
1st Edition (1st printing, October 2018)
© 2018 Glyn Dewis
All images © Glyn Dewis unless otherwise noted

Rocky Nook Inc.
1010 B Street, Suite 350
San Rafael, CA 94901
USA

www.rockynook.com

Distributed in the U.S. by Ingram Publisher Services
Distributed in the UK and Europe by Publishers Group UK

Library of Congress Control Number: 2017963395

This book is printed on acid-free paper.
Printed in Korea

This book is dedicated to my best friend, brother from another mother, and my travel roommate, Dave Clayton.

Acknowledgments

When I first started out in the photography world, I never imagined I'd be writing my own book, let alone writing this, my third. However, one thing is for sure and that is that there are many people in my life whom I have to thank for me getting to this stage where I'm putting words on pages that make some kind of sense—so many, in fact, that acknowledging them all could very easily be book number four.

In the meantime, though, I'll take a moment of your time to mention some of those who have made this book that you have in your hands possible, kicking off with a huge THANK YOU to Scott Cowlin, Ted Waitt, Jocelyn Howell, Mercedes Murray, Lisa Brazieal, and the whole team at Rocky Nook. You folks are world class!

Thanks to those whom I am proud to call my family and friends for your continued support and understanding, and for generally putting up with me as I pursue my love for taking and making pictures in this fantastic creative space.

To my brother, *LIAM*, for being exactly that, my brother. I'm so incredibly proud of the person you are. I love you!

DAVE CLAYTON — I genuinely love you like a brother. We've shared so many laughs, so many experiences, and so many great memories over a relatively short period of time, and there are many more to come. Waiting 38 years to meet my best mate was well worth it!

JOEL GRIMES — I hold so much respect and admiration for you as a photographer, professional, and human being, and also as a friend. Joel, thank you! Without your wisdom, honesty, and willingness to share, I very much doubt I would be doing what I love each and every day. To be able to call both you and Amy friends is the gift I never saw coming!

JOE MCNALLY — No matter how many years on and no matter how much our friendship has developed, the fact that you even know I draw breath makes me giggle like a kid at Christmas who's just been given the present he always wanted. You, sir, are a legend!

ALAN HESS and *AARON BLAISE* (my "other" brothers) — I so hope you guys know what you mean to me. We don't see each other as often as we'd like, but when we do it's like family.

My mate *MATT KLOSKOWSKI* — I learned so much from you when I first started out, and I'm still learning from you today. Anne and I will never forget your thoughtful generosity!

DAVE CROSS – You are, quite simply, one of the best and someone I am so proud to call a friend. What you don't know about Photoshop just isn't worth knowing.

THE TEAM AND FRIENDS (PAST AND PRESENT) AT KELBYONE – All of you have been incredibly supportive and influential throughout my time in this industry. To be in the position where I can publish words about such good people is something I most definitely don't take for granted.

ANTHONY CROTHERS, **IAN MUNRO**, **BRIAN DUKES**, and **GERWYN WILLIAMS** – Hanging out with you guys is the BEST! You totally get what being a friend is all about. No ego, no agenda; just genuinely supportive, kind folks and great mates who make a kick-a$$ team! Time at Skint followed by a curry and chat—it doesn't get better than that!

PAUL GENGE – You are so generous with your advice, thoughts, and support. A top fella and a great friend!

FRIENDS – I could write a whole chapter about the many other great folks who have become friends because of this fantastic, creative industry, but to name just a few: Erik Bernskiöld, Larry Becker, Rick Sammon, Brandon Heiss, Peter Treadway, Peter Hurley, Corey Barker, Julieanne Kost, Dave Black, Moose Peterson, Brian Worley, Terry White, Colin Smith, Mark Heaps, Jesús Ramirez, Kathy Scibetta (Waite), Ed Faith, J.R. Maddox, Kathy Porupski, Steven Cook, Adrian Sommeling, Zack Arias, Gabor Richter, Calvin Hollywood, Frank Doorhof, Justin Wojtczak, Kaylee Greer & Sam Haddix, Rob Sylvan, Jeff Leimbach, Randy Van Duinen, Terry Donnelly, Christian Gram Bredskov, Maciej Blaszczuk, Alexander Schwarz, Sander Sterk, Oliver Kremer, Roberto Palmari, Lauren Kapinos Simons, Greg Rostami, and many more...

THE TEAM AT F.J. WESTCOTT AND J.P. DISTRIBUTION – Not only do you create and supply the best products on the market, but you are a joy to work with.

Finally, to my wife, **ANNE** – There are many times you'll end up sitting home alone while I'm either working away, traveling, or locked away in my den writing, editing, recording videos, or recording podcast episodes with Dave. Your love, support, trust and understanding (which at times I know can't be easy) is what drives me and adds fuel to the fire in my belly. Everything I do, I do for us. I love you so much! x

CONTENTS

Chapter 5
BONUS CONTENT

Chapter 6
PORTRAIT RETOUCHING WORKFLOW

INDEX

To be an artist is a lifelong commitment to something that so many people don't understand or they trivialize. A lawyer, doctor, or accountant—now those are "real" careers. A carpenter, plumber, or mechanic—those are jobs that provide "real" services. In the world in which we live, it's hard to be taken seriously doing something that so many people consider a hobby.

Making art as a career is so much more than a hobby.

Being a professional artist is hard; there's no way around it. You must pour your heart and soul into creating pieces that will move others to see the world in a new light, or at the very least, catch their eye. It's up to you as the artist to filter everything in the world that everyone else sees and experiences every day and turn it into something new and interesting. To take the everyday and reveal it in a new light. This is your job as an artist.

I've been a professional artist for over 30 years now. It's been an incredible journey for me that has brought me so much of every emotion you can imagine. Mostly, though, it's brought me immeasurable amounts of joy.

I've been a fine art painter, illustrator, character designer, animator, film director, and teacher. My career has been a rich one. I spent 21 years at Disney where I had the opportunity to work on some of the most iconic films of our time. Having been a part of *Beauty and the Beast*, *Aladdin*, *The Lion King*, *Pocahontas*, and *Mulan* was an incredible honor. Codirecting *Brother Bear* was one of the hardest things I've ever done in my life. In actuality, all of those films were difficult.

It was our job to create characters and stories that everyone could relate to. We wanted the audience to get behind our characters and cheer for them, cry for them, and fear for them. The only way we could do that was to take what we knew from the world around us and present it in new ways through characters and storylines. This is how we created journeys that the audience wanted to embark on.

What we would create in hundreds of thousands of frames for a film, Glyn does in single images through his photography. When I look at Glyn's work, I tend to fill in the narrative that he is putting forth. His portraiture has depth. His lighting is unique. His compositions are bold. All of these qualities add up to single-image story telling.

This is where I feel Glyn's and my work overlap so perfectly. We are both image makers. We both struggle to tell stories through our work. We both must find the right light, composition, color, and expression. We both need to make it all add up to something.

For so many years the tools of our trades were so different from one another. Mine being paint, canvas, and brushes; his being camera, film, and darkroom; but with the arrival of the digital age, even our tools overlap now.

Glyn and I both use Photoshop in our work. One of the things I love about Photoshop is the ability for each user to really make it work for them. Glyn and I have spent years exploring Photoshop, each trying to make it our own. It still amazes me, though, when Glyn and I get together, how we use many of the same tools to create completely different results. I love that! We have different results, but very similar concerns throughout the process. We both strive to find the right light and shadow, color, and composition. In the end, we both have all of the same elements, but I have a digital painting and Glyn has a digital photograph. Hopefully both tell a story.

After digesting all of what this book has to offer, you will come to understand the tools and their uses and will make them your own as well. Then it will be your turn to tell your own stories.

Not a bad "hobby."

Aaron Blaise

My wonderful brother, Liam

I can distinctly remember when I first started using Adobe Photoshop. I was briefly introduced to it by an uncle who showed me how to remove red eye from portraits of family members about 11 years or ago, and I was hooked. Maybe I shouldn't admit it, but back then I managed to get myself a copy of Photoshop and I remember being so excited to start playing. I loaded it into my Gateway computer with its 19-inch monitor (that had a depth of about 38 inches), but once the welcome screen was gone I didn't have a clue where to go next. Menus, dialog boxes, something called a toolbar, and more...man, I was really confused. But I think, in fact I know, this is quite a normal reaction.

Photoshop is a huge piece of software. It's only limitation is the imagination and skill of the person using it. However, after using it for the past few years, I truly believe that anyone can learn how to use it and, with plenty of regular use and practice, feel at home with it.

Now, you'd probably expect me to say this, but with this book at your side you will start to feel more confident with Photoshop. After using this software on an almost daily basis for the past few years, I believe there are just three main things you need to know in Photoshop. I'm not talking an in-depth, advanced understanding, but rather a basic understanding of three things: layer masks, brushes, and blend modes.

Sure, there's lots more to Photoshop than layer masks, brushes, and blend modes, but if you know how to use these three tool groups, then all that's left is practice. Whether you're looking at what work has gone into retouching a simple portrait or what went into creating an incredibly detailed composite, layer masks, brushes, and blend modes will be at the heart of it.

What Is the Photoshop Toolbox?

Whether you're new to Photoshop or you have been using it for a while, you likely know that there is never one single technique that gets you perfect results for every picture you use it on. Because of this, my advice is always to get to know as many techniques as you can that do the same kind of thing, so that when you do come across a situation when, for example, your favorite skin smoothing technique isn't working so well, you'll have another technique in your toolbox that you can take out and try.

About This Book

This book is split into a few distinct sections. We start off with what I'm calling "The Basics," which is where I cover layers. I guess I could have included layers as the fourth area you need to know in Photoshop, but as I see it, layers *are* Photoshop. If we don't know what they are and how to use them, then we'll still be staring at the welcome screen like I did when I first started. So, if you don't quite get what layers are, then chapter 1 is a MUST. Don't skip it; otherwise, nothing we do in the rest of the book is going to make sense. Okay?

In chapter 2 we'll take a look at layer masks. Once I've explained what these are so that you understand exactly why you'd be interested in them, we'll start looking at how we can use layer masks in our workflow to save time, in our retouching, to create special effects, and more.

Chapter 3 is where we take a look at brushes. When I first started using Photoshop, I thought that the brushes were only for those folks who can draw (and I am most definitely not one of those people), but oh how wrong I was! Brushes are an incredibly powerful tool in Photoshop and you'll find that there are seemingly endless ways to use them. They are, without a doubt, one of my favorite tools in Photoshop for creating effects and retouching.

In chapter 4 we look at blend modes. This is where magic really can happen. Don't worry, we won't go into all the mathematics of why they do what they do, but you will come away from this chapter with a greater understanding that will ultimately help you move forward as I cover various techniques that range from basic to advanced.

I thought it would be good to add in a bonus chapter with some of my favorite tips, tricks, and techniques not covered elsewhere in the book, so look for those in chapter 5.

It's great to learn about lots of different techniques, and there are plenty of them in this book, but there's no better way to cement this new information in your brain than to use these techniques in a workflow—that's where chapter 6 comes into play. We'll work our way through a complete retouching project from start to finish, beginning with an out-of-the-camera file and following through to the final print-ready image.

As you work with this book, you'll discover that working in Photoshop is very much a personal practice, and what you do and the order in which you do it doesn't have to be regimented. Remember, there is no right or wrong way to do something in Photoshop; there are simply good and bad results. You use the techniques how and when you choose because it's your Photoshop Toolbox!

How to Use This Book

The best way to learn is to follow along, so make sure you download the files for this book at the link found at the bottom of this page.

To get the most out of this book you don't necessarily need to start at the beginning and work your way through page by page. I've written it in such a way that you can simply dive in and out. However, like I said before, if you're fairly new to Photoshop and don't quite understand the whole layers thing, I'd definitely recommend you check out chapter 1, "The Basics."

What I really want this book to do is encourage you to approach Photoshop with the mindset of "what would happen if...?" Once you've gone through a technique, think about where else you could use it, or even how you could adapt it. Experiment. Take sliders to their minimum and then to their maximum—what does that do? Try different blend modes to see how they affect your image. You can't break Photoshop (I'll show you what to do in case of emergencies in chapter 1), so just experiment and play with it because that's how new techniques are discovered.

Finally, before you get started, I'd like to thank you so much for purchasing this book. Please keep me posted with your progress. I'd love to see anything that you go on to create, and hear about your successes having used some of what is contained in the pages ahead.

Keep creating, but most of all, keep enjoying!

Best wishes,
Glyn

*Download all the files you need
to follow along step-by-step at:
http://rockynook.com/pstoolbox*

glyndewis.com
youtube.com/glyndewis
instagram.com/glyndewis
facebook.com/glyndewis
twitter.com/glyndewis

BASICS

PS

Before we dive into the goodness that is layer masks, brushes, and blend modes, I thought it would be a good idea to go over some of the basics of Photoshop, just in case you click on something you didn't mean to or press a number of keys in quick succession that causes Photoshop to throw a hissy fit (as I have done more times than I care to remember).

We'll take a quick tour of the Photoshop workspace and discuss how you can rearrange and organize it to suit how you work. We'll also go through how you can tidy up and put everything back into place quickly and easily, should you need to. But first, we'll take a look at the basics of layers: what they are, how to use them, and what working non-destructively is all about.

If you're a seasoned Photoshop user who understands layers and already knows how to organize the Photoshop workspace, then feel free to skip past this bit and dive straight into chapter 2 and beyond.

Right, let's get going...

LAYER BASICS

The best explanation of layers I've ever read came from my friend Matt Kloskowski in his aptly named book *Layers*, which was published in 2008, but is still as relevant today as it was then. (Thanks, Matt, for giving me the "all clear" to cover layers in this book the way you did in yours.)

Think of layers like this: Imagine you have a very special photograph. You'd never in a million years think of drawing on it with a Sharpie and then later trying to erase what you'd done, would you? Well, that's exactly what you would be doing if you didn't use layers in Photoshop, and instead made all of your adjustments to the original image.

If you were going to draw over your photograph, you'd probably create a copy first, or better yet, use some clear acetate sheets and draw on those. That way the original photograph would remain safe and intact. Let me show you what I mean.

1. So here we are with a photograph of my best mate, Dave Clayton, and just for giggles we'll give him a moustache, blacken out a front tooth, and color in one of the lenses of his glasses (**Figure 1.1**).

2. So what do we do now if we want to change or maybe even erase the black ink we've just used to draw on the photograph? It certainly won't be easy. We might start rubbing on it with a cloth, but that's dangerous because we may end up erasing not only the ink, but some of the photograph, too. Yep, at this point we're pretty much stuck with it (**Figure 1.2**).

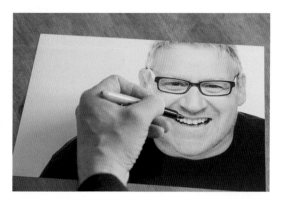

FIGURE 1.1

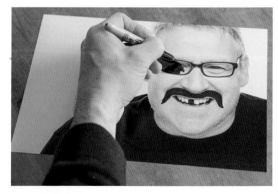

FIGURE 1.2

3. Okay, let's rewind and do this again, but this time we won't mess up the original photo. Let's say we still want to draw on the picture for a giggle, but this time we'll do it with a piece of clear acetate (**Figure 1.3**).

4. Now instead of drawing directly onto the photograph, we'll place the clear acetate on top of it so that we can still see the picture beneath and draw on the acetate instead. Everything still looks the same, right (**Figure 1.4**)?

5. Now let's imagine that we want to erase what we just drew. Well, that's easy—we can just remove the sheet of acetate we drew on, and the picture below is untouched and intact (**Figure 1.5**). By drawing on the acetate on top of the photograph, we've achieved the same result, but we used a much more flexible method that allows us change it later if we want to. Does that make sense?

FIGURE 1.3

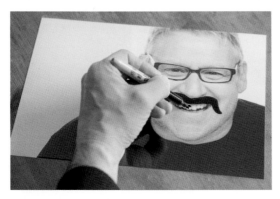

FIGURE 1.4

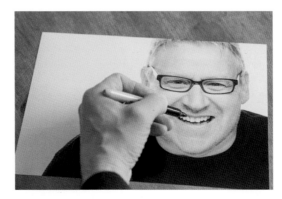

FIGURE 1.5

Let's compare this process to using Photoshop:

1. Open the **dave.jpg** file in Photoshop and choose the Brush Tool (B) from the toolbar (**Figure 1.6**). Click on the brush size drop-down in the options bar at the top of the screen to open the Brush Preset picker, and select a round, hard-edged brush (**Figure 1.7**). Press D to set your foreground and background colors to their defaults of black and white (press X to swap foreground and background colors if needed), and then draw directly on the Background layer just like we did before (**Figure 1.8**).

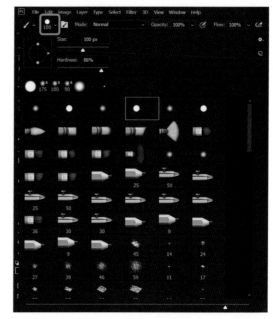

FIGURE 1.6 FIGURE 1.7

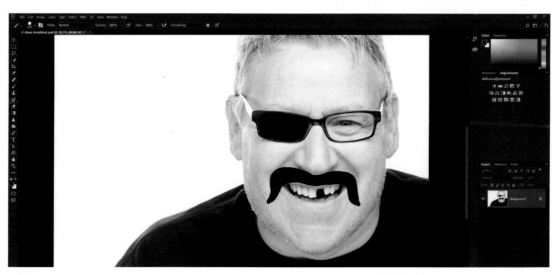

FIGURE 1.8

Download all the files you need to follow along step-by-step at: http://rockynook.com/pstoolbox

2. So now you've drawn over Dave's face, and let's just say you've changed your mind and don't want him to have a moustache after all. Grab the Eraser Tool (E) from the toolbar and start brushing directly onto the picture to erase the parts you don't want. The trouble here is that you end up erasing not only the moustache, but parts of the picture as well (**Figure 1.9**—you see white here because the background color in the toolbar is set to white). Obviously, this isn't a good way to work, so how can we use Photoshop like we did before with the clear acetate? Close this image (making sure not to save what you've just done), and let's look at a better way to work in Photoshop.

3. Open the clean picture of Dave in Photoshop one more time. This time, before using the Brush Tool, click on the Add New Layer icon (which looks like a sheet of paper with a folded corner) at the bottom of the Layers panel to add a new blank layer (**Figure 1.10**). This new layer, which is labeled Layer 1, will be positioned on top of the picture of Dave in the Layers panel. This gives us the same setup as the photograph of Dave with the clear acetate on top of it, but this time it's in digital form.

NOTE *You can change the name of the new layer by double-clicking on the words Layer 1 in the Layers panel and typing in a new name.*

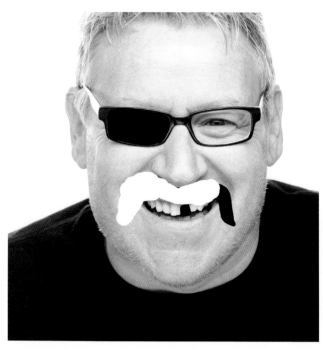

FIGURE 1.9

FIGURE 1.10

4. Make sure Layer 1 is selected in the Layers panel, and then use the black, round, hard-edged brush to draw over Dave's face in the main workspace once again. Whatever you draw with the brush will appear on the Layer 1 thumbnail over in the Layers panel (**Figures 1.11** and **1.12**).

> **NOTE** *You need to click on a layer in the Layers panel to select it and make it active. You can tell when a Layer is selected because it will be highlighted in a different color (e.g., gray, blue, etc.).*

FIGURE 1.11

5. Now comes the magic of using layers. Make sure Layer 1 is still active and, just as before, select the Eraser Tool and brush over the moustache to erase it (**Figure 1.13**). Notice that this time only the black brushstrokes are being erased, and the original picture of Dave stays intact.

This is what is commonly known as nondestructive retouching. The original image is completely safe and untouched, and when you save the file with all the layers intact, you can make changes at any time in the future. Cool, huh?!

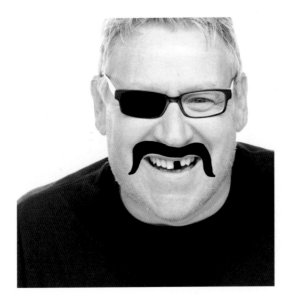

FIGURE 1.12

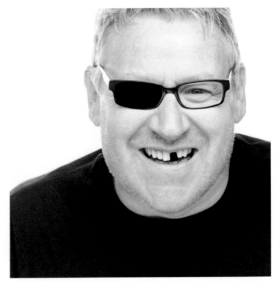

FIGURE 1.13

LAYER GROUPS

Now that we've covered the principle of layers, let's look at one more thing before we move on to the Photoshop workspace and dive into the really cool stuff.

When you're working in Photoshop it can be very easy to generate a lot of layers—so many that it becomes difficult to know what each layer does. For example, while working on **Figure 1.14**, you can see that I created six different layers to colorize the picture (**Figure 1.15**). This is where it really helps to be organized, and the way to do that is to use layer groups.

It makes sense to keep layers that are related to one another in groups so that they are easier to find. Grouping layers also allows you to do other cool stuff like use layer masks and blend modes on all of the layers in the group at once. We'll cover this later in the book. For now, let's walk through how to create a group.

FIGURE 1.14

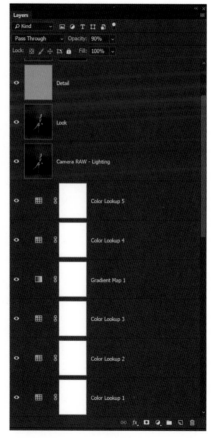

FIGURE 1.15

Use the following steps to put related layers into a group:

1. Click on the first layer that you want to add to a group, hold down the Shift key, and then click on the last layer. This will highlight the first and last layers as well as all the layers in between (**Figure 1.16**).

2. With all the layers highlighted, go to *Layer > New > Group from Layers*, and in the New Group from Layers properties, give the group a name. In my example, I've named the group **color** (**Figure 1.17**). Click OK.

3. Notice in **Figure 1.18** that all the layers I selected have been placed into the color group in the Layers panel. To open and close the group, simply click on the small arrowhead icon to the left of the group folder.

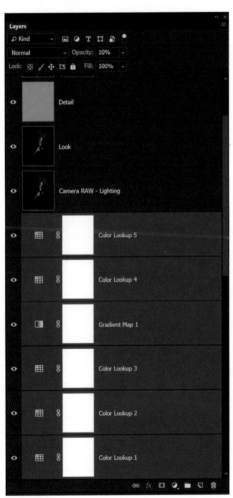

FIGURE 1.16

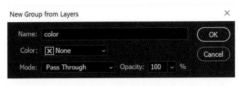

FIGURE 1.17

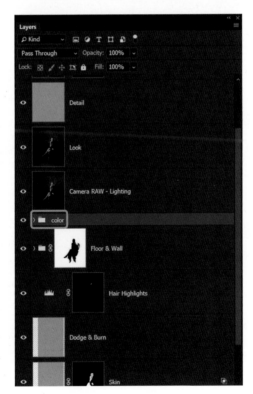

FIGURE 1.18

WORKSPACE

Just in case you're not completely familiar with the Photoshop workspace, I thought I'd point out where you'll find stuff and what's what. I'll cover the default layout of Photoshop, but seeing as how Photoshop is your personal toolbox, you can rearrange everything to suit your own way of working.

The Start Screen Workspace

When you first open Photoshop (CC) you're presented with the Start workspace (**Figure 1.19**). This screen also appears when you create a new document. From here you have a choice of creating a new document, choosing a new document from premade templates, or opening a previous document. Depending on your subscription status, you may also be able to search Adobe Stock and check out a Photoshop learning area that gives an overview of tools and other features.

 TIP *You can customize how many recent files are visible in the Start workspace by going to* Photoshop CC > Preferences > File Handling *and typing any number from 0 to 100 into the Recent File List Contains field at the bottom of the Preferences dialog.*

If you'd rather not see the Start workspace every time you open Photoshop, you can disable it by going to *Photoshop CC > Preferences > General* and removing the check mark next to the box that says Show "Start" Workspace When No Documents Are Open.

FIGURE 1.19 The Photoshop Start workspace

THE PHOTOSHOP WORKSPACE

Figure 1.20 shows the default Photoshop workspace.
I've marked up the areas I'll refer to throughout the book.

FIGURE 1.20

Adjustment layers

Layers panel

Customizing the Photoshop Workspace

As we've discussed, Photoshop is your toolbox, so you can arrange it however you'd like, and there's so much more you can do than simply putting tools in different places.

MOVING PANELS If you click on the name of a panel you can drag it to a different location in the workspace (**Figure 1.21**). You can also place it among other panels in the workspace by dragging it on top of another panel. Once you see a blue outline where you want the panel to be located (**Figure 1.22**), release the mouse to drop the panel into place. To minimize the panel, simply double-click on its name (**Figure 1.23**).

CLOSING PANELS To close a panel, right-click on panel name and choose Close from the context menu (**Figure 1.24**).

OPENING PANELS There may be times when you can't see a certain panel that you need. If this is the case, all you need to do is go to the Window menu at the top of your screen and click on the name of the panel you want to add to your workspace (**Figure 1.25**). The panel names with check marks next to them are already visible in the Photoshop workspace, so clicking on them in the Window menu will close them.

PRESET WORKSPACES There are a number of preset workspaces from which you can choose, which Adobe has set up with what they consider to be the relevant panels for specific types of work. These include Essentials (Default), 3D, Graphic and Web, Motion, Painting, and Photography. To choose one of these workspaces, go to *Window > Workspace* and click on your preferred choice (**Figure 1.26**).

FIGURE 1.21

FIGURE 1.22 Blue outline showing where Properties panel will be relocated

FIGURE 1.23 Properties panel repositioned and minimized

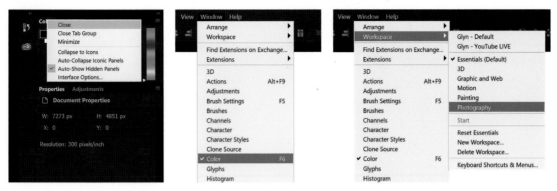

FIGURE 1.24 Closing a panel FIGURE 1.25 FIGURE 1.26

SAVING A CUSTOM WORKSPACE You can also save your own custom workspace with any of the panels, keyboard shortcuts, menu items, and toolbar items that you have arranged to suit your needs. To do this, once you have rearranged the workspace, go to *Window > Workspace > New Workspace* (**Figure 1.27**). In the dialog box, give your workspace a name and select whether you would like to save any keyboard shortcuts, menus, or the toolbar configuration (panel locations are always saved). Click Save, and your custom workspace will now be available for selection in the *Window > Workspace* menu.

RESETTING THE WORKSPACE Finally, if you've moved stuff around in a particular workspace and decide you just want everything back in its original configuration, you can reset the workspace by going to *Window > Workspace > Reset* (followed by the name of the workspace you are currently using) (**Figure 1.28**).

There's so much more you can do with the Photoshop workspace; in fact, I could probably write a book on that topic alone. However, that's not my intention here. I just wanted to give you an idea as to where you can find areas I'll be referring to, how to rearrange them to suit your preferences, and most importantly, what to do if it all starts to look a bit strange.

I highly recommend you check out the following webpage, where Adobe has covered workspace customization in much more detail: https://adobe.ly/2v7tG78.

FIGURE 1.27

FIGURE 1.28

LAYER MASKS

2

When Photoshop was first released it didn't even contain layers, let alone such things as layer masks. I can't imagine how challenging and time-consuming it must have been to perform certain tasks without these features. I started using Photoshop when version CS was released, so layers and layer masks have always been the norm for me, and boy am I glad. As you'll see in this chapter, layer masks can save you so much time and heartache when it comes to working nondestructively because they allow you to correct mistakes quickly and easily without having to redo lots of work.

We'll kick off this chapter by looking at what layer masks are and when and why you would use them. Then we'll go over how you can use them to realistically blend pictures, create special effects, make selections and cutouts, and more.

If you've never used layer masks before, I guarantee you'll quickly see how invaluable they are, and you'll be grateful you have them, unlike those poor folks back in the early days of Photoshop.

WHAT ARE LAYER MASKS?

Rather than trying to tell you what layer masks *are*, I think it's best to talk about what they do. In the simplest terms, layer masks allow us to show or hide all or parts of a layer. (We can also use them on layer groups, but we'll cover that a little later on.)

Layer masks come in two colors—namely, black and white. There's a saying I heard when I first started using Photoshop that has stuck with me ever since and helps me remember the difference between the two colors: white reveals, black conceals. Let me explain.

As an example, we'll use a portrait of kickboxer Steven Cook. Let's imagine that we want to convert the picture to black and white, but keep the red on his boxing gloves and shirt. Without layer masks, you might consider doing it like this:

1. Open the **kickboxer.jpg** file in Photoshop and create a duplicate by pressing Ctrl + J (PC) or Command + J (Mac). Double-click on the name of the new duplicate layer, which at this point will be Layer 1, and rename it **Black and White (Figure 2.1)**.

2. Go to *Image > Adjustments > Desaturate* to remove all the color from the duplicate layer (**Figure 2.2**).

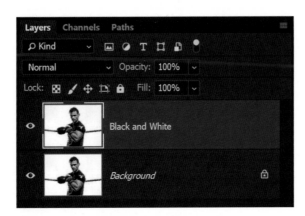

FIGURE 2.1

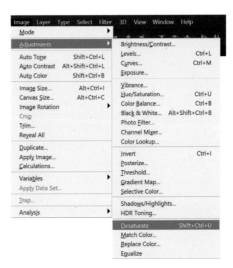

FIGURE 2.2

Download all the files you need to follow along step-by-step at: http://rockynook.com/pstoolbox

3. Now choose the Eraser Tool (E) (**Figure 2.3**) and erase parts of the Black and White layer on Steven's shirt and gloves so that you can see the color layer beneath (**Figure 2.4**).

Although we have achieved the effect we were after by using the Eraser Tool, what happens if we erased too much, or saved the file and now want to make changes to it?

By using the Eraser Tool we have actually deleted parts of the Black and White layer. You can see the areas that have been deleted by clicking on the eye icon next to the Background layer thumbnail in the Layers panel (**Figure 2.5**).

FIGURE 2.3

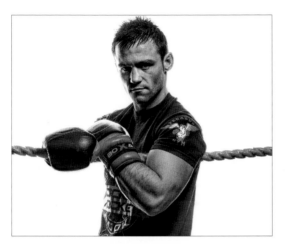

FIGURE 2.4

FIGURE 2.5

This turns the Background layer off, and you now see only the Black and White layer in the main workspace (**Figure 2.6**). Look at the parts of the layer that are missing (the areas where you see a checkerboard pattern)—these are the bits you've erased, making holes in the layer so that you can see through to the layer beneath it.

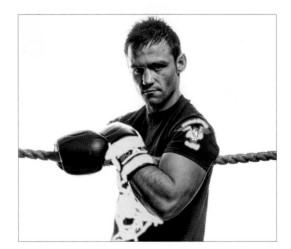

FIGURE 2.6

So now what if we decide we want to make changes to the image so that the red is visible on the boxing gloves, but not on Steven's shirt? This would mean we'd have to delete the Black and White layer, create a new duplicate layer, convert the new layer to black and white with the Desaturate command, and then use the Eraser Tool again, right? Wrong! With layer masks we can do it a whole lot quicker and easier from the start. Let's see how:

4. With the original image open in Photoshop, create a duplicate by pressing Ctrl + J (PC) or Command + J (Mac). Double-click on the name of the new duplicate layer, which at this point will be Layer 1, and rename it Black and White.

5. Go to *Image > Adjustments > Desaturate* to remove all the color from the duplicate layer.

6. The next step is to add a layer mask. This can be done in a number of ways, but for now, click on the Add a Layer Mask icon at the bottom of the Layers panel (the rectangle with a circle in the middle, third icon from the left; **Figure 2.7**). This is the method you'll use most of the time.

Now that you've done this, take a look at the layers in the Layers panel. The Black and White layer now has a white thumbnail to the right of the image thumbnail and there is a chain between the two (**Figure 2.8**). This shows that a layer mask that is now attached to the Black and White layer. Earlier I mentioned that layer masks are either black or white. The layer mask you've just added is white, meaning you can see all the contents of the layer it is attached to. White reveals, black conceals—you with me?

FIGURE 2.7

FIGURE 2.8

7. Now comes the magic of layer masks. Choose a simple round brush (B) from the toolbar (**Figure 2.9**), make sure the Opacity is set to 100% in the options bar at the top of the screen (**Figure 2.10**), and press D to set the foreground color to black (**Figure 2.11**). (To swap the foreground and background colors, press X.)

FIGURE 2.9

8. Now you're all set. Paint over the boxing gloves and Steven's T-shirt, and as you do you'll notice that the red color from the layer beneath shows through (**Figure 2.12**).

This isn't any different than when we first did it, right? Wrong!

What's happening here is that by painting on the layer mask in black, you are hiding parts of the Black and White layer, which allows the underlying layer (the Background layer with the color) to show through.

To see where you've painted the layer mask, hold down Alt (PC) or Option (Mac) and click once on the layer mask thumbnail attached to the Black and White layer in the Layers panel. You'll see your black brushstrokes in the areas you brushed over to hide parts of the Black and White layer and reveal the color on the layer below (**Figure 2.13**). To go back to the normal view hold down Alt (PC) or Option (Mac) and click on the layer mask thumbnail again.

FIGURE 2.10

FIGURE 2.11

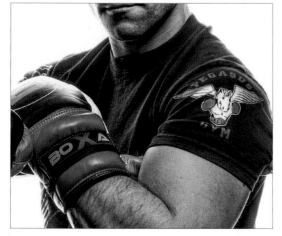

FIGURE 2.12

FIGURE 2.13

The best thing of all about this is that this is completely nondestructive, meaning we can make changes to it at any time. Here's how:

9. Make sure the layer mask is still selected in the Layers panel, and then press X to change the foreground color to white.

10. Paint over the red boxing gloves once more. Notice that now the Black and White layer becomes visible again (**Figure 2.14**). This is because wherever you paint in white on the layer mask, you reveal that portion of the layer to which the mask is attached. White reveals, remember?

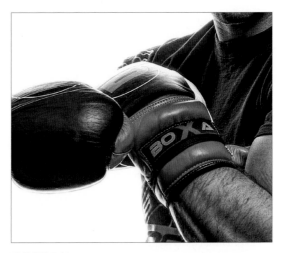

FIGURE 2.14

Being able to jump back and forth painting in white or black means we can easily finesse whatever it is we want to reveal or conceal. Revealing too much? Then simply paint in black to cover over the excess, and vice versa.

*NOTE Before painting on a layer mask, make sure it is active. You can tell it is active when it has a frame around it in the Layers panel (**Figure 2.15**). If you don't see a frame around the layer mask, simply click on it once to select it.*

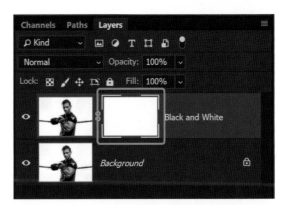

FIGURE 2.15

In this example, if the layer mask had not been active, you would have been painting with black directly on the picture (**Figure 2.16**).

Now that we've covered the basics, let's take a look at some practical uses for layer masks when working on pictures in Photoshop, making use of both black and white layer masks.

FIGURE 2.16

MAGAZINE TEXT EFFECT

On the cover of pretty much every magazine, there is text that is partially covered by a cover model's head or body, or whatever the subject may be (**Figure 2.17**). But how do the designers do that? With layer masks, of course. Let's try it.

1. Open the **magazine.jpg** file in Photoshop and select the Text Tool (T). Click on the font drop-down menu and choose Mongolian Boiti (**Figure 2.18**). (You can choose whatever font you like if you don't see this particular one.) Click somewhere on the top part of the picture and type IMAGING (in all capital letters; **Figure 2.19**).

FIGURE 2.17

FIGURE 2.18

FIGURE 2.19

2. The text should be centered, so we need to tell Photoshop what we want the text to be the center of (in this case, the picture). Go to *Select > All,* and you'll see what is called "marching ants" appear around the perimeter of the picture, indicating that it is selected (**Figure 2.20**). Select the Move Tool (V) from the toolbar (**Figure 2.21**), and then click on the Align Horizontal Centers icon in the options bar at the top of the screen (**Figure 2.22**).

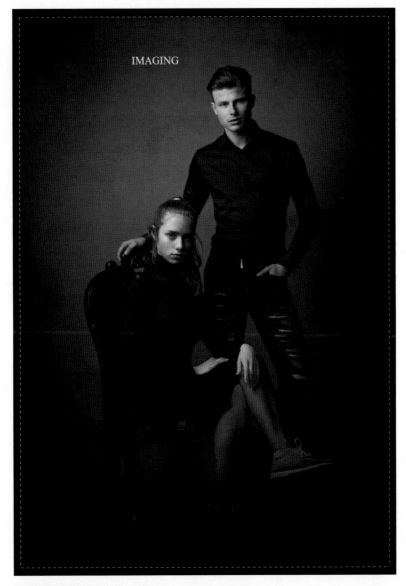

FIGURE 2.20

FIGURE 2.21

FIGURE 2.22

3. The text has been centered and now we need to make it bigger. Go to *Select > Deselect* to get rid of the marching ants, and then go to *Edit > Free Transform.* Hold down Shift + Alt (PC) or Shift + Option (Mac) as you click and drag outward on the upper-left or upper-right transform handle to enlarge the text (**Figure 2.23**).

4. Press Enter (PC) or Return (Mac) to set the text in place, and then click on the Add Layer Mask icon at the bottom of the Layers panel to add a layer mask to this text layer (**Figure 2.24**).

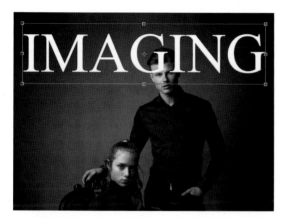

FIGURE 2.23

FIGURE 2.24

5. Make sure the layer mask is active (has a frame around it in the Layers panel), grab a regular round brush (B) from the toolbar, and press D to set the foreground color to black (press X to swap the foreground and background colors, if necessary). Now paint over the portion of the text that is covering the male model's head to hide (conceal) it (**Figure 2.25**). White reveals, black conceals! While painting on the layer mask, you may find it helpful to lower the opacity of the text layer so you can see the male model's head through it, making it easier to see where you need to paint with the brush (**Figure 2.26**). Once you're finished, set the opacity of the text layer to whatever you want.

 TIP *To quickly decrease or increase the size of the brush, press the left and right square bracket keys [] on the keyboard.*

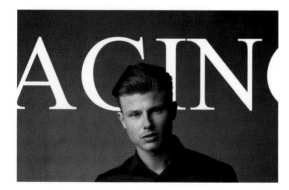

FIGURE 2.25

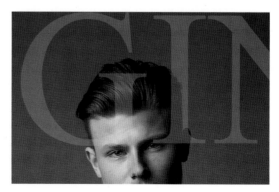

FIGURE 2.26

LAYER MASKS WITH SELECTIONS

You may find that when you're working with a brush to hide (conceal) the text covering the male model's head, it can be quite difficult to brush over the stray hairs and make it look realistic. In situations like this, we can make a selection of the male model first, and then use a layer mask.

Let me show you what I mean:

1. Follow steps 1–4 in the previous section to set up the text layer and layer mask. With the text layer in place, turn off its visibility by clicking on its eye icon in the Layers panel, and then click on the Background layer to make it active (**Figure 2.27**).

2. Grab the Quick Selection Tool (W) from the toolbar, and then click and drag over the male model to make a selection (**Figure 2.28**). To remove the selection from an unwanted area, hold down the Alt (PC) or Option (Mac) key as you click and drag the marching ants away from that area and toward where you want the selection to end.

FIGURE 2.27

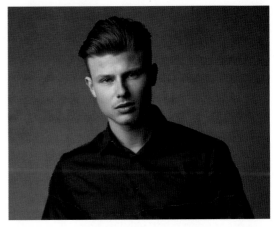

FIGURE 2.28

3. With a selection around the male model, click on Select and Mask in the options bar (**Figure 2.29**). (Refine Edge in earlier versions of Photoshop works great for this, too.) In the Select and Mask dialog, click on the box next to Smart Radius and increase the Edge Detection to around 6px (**Figure 2.30**). This will help Photoshop to find some of the stray hairs that were missed by the Quick Selection Tool.

FIGURE 2.29

FIGURE 2.30

NOTE *You can change the Select and Mask View Mode to*
suit your preference. Simply click on the View drop-down
menu in the Properties panel and select the one you'd like
*to use (**Figure 2.31**).*

4. Grab the Refine Edge Tool from the toolbar (**Figure 2.32**) and drag around the outside of the male model's head to see if Photoshop can pick up any extra-fine hairs to make the selection even better. When you're done, go over to the Output Settings section of the Select and Mask Properties panel, choose Selection from the Output To menu, and click OK (**Figure 2.33**).

5. Now you should be back in the Photoshop workspace with an active selection around the male model. Make the text layer visible again by clicking on its eye icon Layers panel, and then click on the layer mask thumbnail so that it has a frame around it, meaning that it is active (**Figure 2.34**).

FIGURE 2.31

FIGURE 2.32 FIGURE 2.33

FIGURE 2.34

6. Go to *Edit > Fill,* select Black from the Contents drop-down menu, and click OK (**Figure 2.35**). This fills the active selection area (around the male model) on the layer mask with black, and the black is now hiding (concealing) the text in this part of the picture. It looks a lot better this time since we made the effort to select the hair rather than brush over it.

7. Go to *Select > Deselect* to get rid of the marching ant selection (**Figure 2.36**).

In my final picture, I went on to add more text layers and I lowered the Opacity of all of them to 10% (**Figure 2.37**).

FIGURE 2.35

FIGURE 2.36

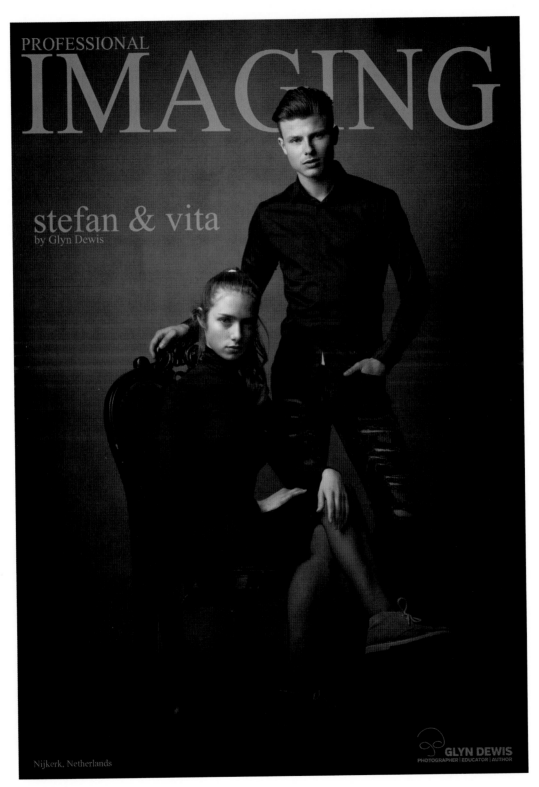

Nijkerk, Netherlands

FIGURE 2.37

REPLACING SKY

I mentioned in the introduction how I want to encourage you to experiment with techniques. So often we see a technique and think that it can only be used for doing that one specific thing, but this most definitely is not the case.

We've just gone through how you can use layer masks to make it look as though text is behind a person on a magazine cover, but now let's look at how we can use the exact same technique to replace the sky in a completely different picture.

I took the photograph shown in **Figure 2.38** during a visit to the Black Country Living Museum in Dudley, West Midlands, where they film the television drama *Peaky Blinders*. When photographed with the beautiful blue sky behind it, the statue became a silhouette. In order to bring out more detail on the statue I had to use exposure compensation, but because the exposure was increased, all detail in the sky was lost as it got brighter (**Figure 2.38**). Let's use layer masks to replace it.

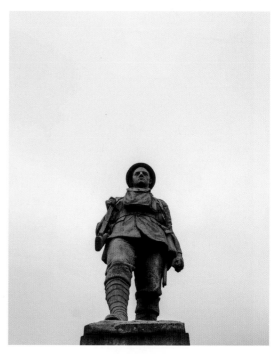

FIGURE 2.38

1. With the **statue.jpg** file open in Photoshop go to *File > Place Embedded* (**Figure 2.39**; or *File > Place* in earlier versions of Photoshop). Navigate to the **sky.jpg** file, select it, and click OK. This opens the sky.jpg file and places it at the top of the layer stack, above the statue (**Figure 2.40**).

FIGURE 2.39

FIGURE 2.40

2. Go to *Edit > Free Transform* and, just as before when we enlarged the text in the magazine exercise, hold down Shift + Alt (PC) or Shift + Option (Mac) as you click and drag the upper-left or upper-right transform handle outward until the clouds completely cover the statue (**Figure 2.41**). Press Enter (PC) or Return (Mac) to set the sky in place.

FIGURE 2.41

3. Turn off the visibility of the sky layer by clicking on its eye icon in the Layers panel, and then click on the Background layer (statue) to make it active (**Figure 2.42**). Choose the Quick Selection Tool (W) from the toolbar and drag around the statue to make a selection (**Figure 2.43**).

FIGURE 2.42

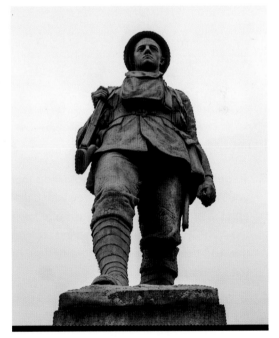

FIGURE 2.43

4. With an active selection around the statue, turn on the visibility of the sky layer by clicking on its eye icon. Now you can see the sky with the active selection of the statue (which, for some reason, makes me think of the film *Predator* with Arnold Schwarzenegger) (**Figure 2.44**). Click on the sky layer to make it active.

Next we want to use a layer mask on the sky layer so that we can see the sky, but hide the area within the active selection to reveal the statue on the layer below.

If you click on Add Layer Mask at this point, Photoshop will add a white layer mask by default. Because there is an active selection, Photoshop will think that you want the white part of the mask to be within the selection and the black part to be on the outside. If you do this, you will see the sky within the selection, and it will be hidden from the area around the selection, revealing the washed-out sky from the Background layer below (**Figure 2.45**).

FIGURE 2.44

FIGURE 2.45

5. To get around this and tell Photoshop that you want to fill the selected area with black and the area outside with white, hold down the Alt (PC) or Option (Mac) key and click on the Add Layer Mask icon at the bottom of the Layers panel.

6. This adds a layer mask with the selected area filled with black, meaning the sky is hidden (concealed) so that you can see the statue below, and the white part of the mask covers the surrounding area so you can see the sky (**Figures 2.46** and **2.47**). All clear?

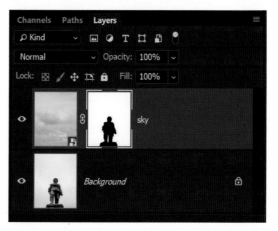

FIGURE 2.46 Holding down the Alt (PC) or Option (Mac) key and clicking on Add Layer Mask fills the active selection with black and the surrounding area with white.

FIGURE 2.47

What's that chain icon all about?

When you see the chain icon between the layer and layer mask thumbnails in the Layers panel, it means that the layer mask is firmly attached to the layer and locked in position. However, if you click on the chain icon to turn it off, you can move the layer and layer mask independently of each other.

Why would you want do this? Well, in this example, it means you could reposition the sky.

1. Click on the chain icon on the sky layer to turn it off, and then click on the sky thumbnail to make it active (it will have a frame around it) (**Figure 2.48**).

2. Choose the Move Tool (V) from the toolbar and then click and drag directly on the sky in the picture to move it around and show whichever part you prefer (**Figure 2.49**). When you've positioned the sky where you want it, click on the area between the sky and layer mask thumbnails to make the chain icon active again and lock the layer and layer mask together.

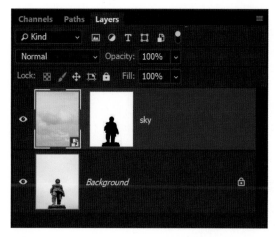

FIGURE 2.48

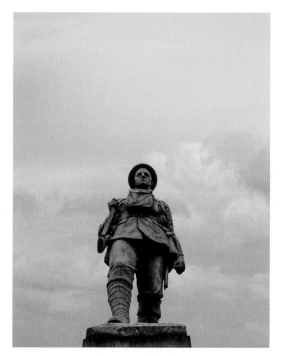

FIGURE 2.49

CLIPPING MASKS

Seeing as how we're talking about layer masks, now seems as good a time as any to mention another type of mask in Photoshop: the clipping mask. Rather than explain what a clipping mask is, let me show you.

Carrying on with our statue picture, let's make the sky a little more vibrant and saturated. To do this we'll use a Vibrance adjustment layer.

1. Click on the Vibrance icon in the Adjustments panel to add a Vibrance adjustment layer (**Figure 2.50**). Notice how adjustment layers have layer masks attached to them (**Figure 2.51**)? We'll cover this a little later.

FIGURE 2.50

2. In the Vibrance Properties, drag the Vibrance slider to +40 and the Saturation slider to +30 (**Figure 2.52**). When you do this, you'll notice that the colors in the picture (the blues mainly) have become much more vibrant and saturated. At the moment, this adjustment layer is affecting the entire picture, but we want it to affect only the sky. To do this we will use a clipping mask.

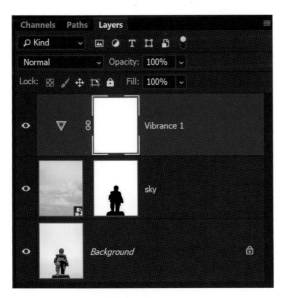

FIGURE 2.51

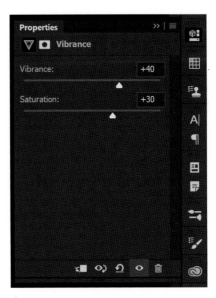

FIGURE 2.52

3. Click on the Clipping Mask icon at the bottom of the Vibrance Properties panel (it looks like a little square with a downward-pointing arrow next to it; **Figure 2.53**). You'll notice in the Layers panel that to the left of the adjustment layer there is now a right-angled arrow pointing down (**Figure 2.54**). This means that the clipping mask has been applied to the adjustment layer and as a result, the Vibrance adjustment is only visible on the visible parts of the layer below. In this example, the layer below has a layer mask attached to it, so the only visible parts of that layer are the parts covered in white (i.e., the sky); therefore, the Vibrance adjustment layer only affects the sky. Clever, huh?

FIGURE 2.53

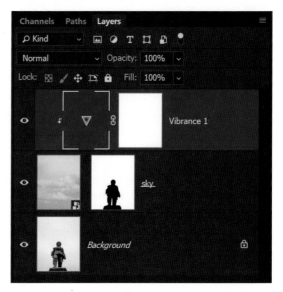

FIGURE 2.54

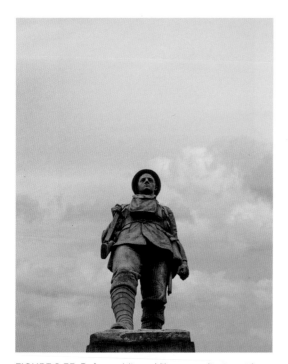

FIGURE 2.55 Before adding a Vibrance adjustment layer

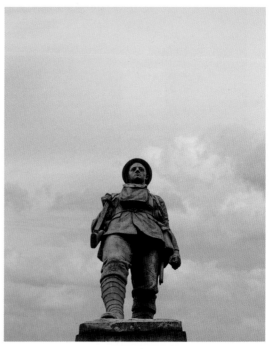

FIGURE 2.56 With a Vibrance adjustment layer

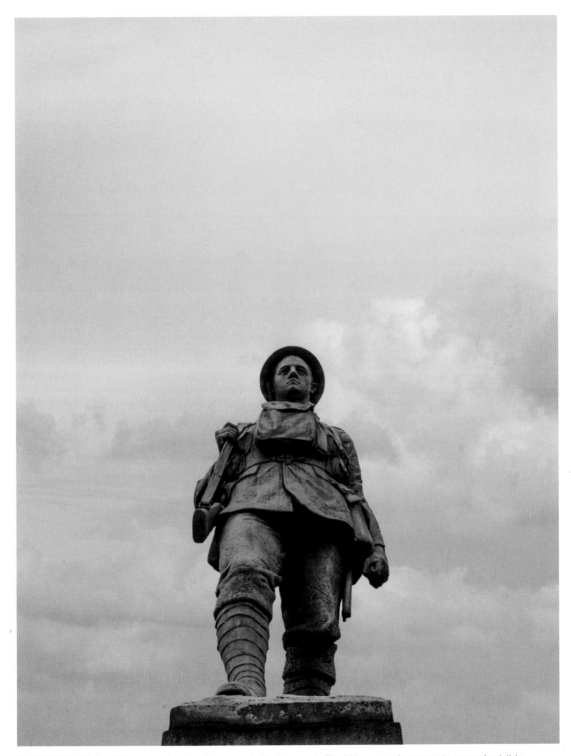

FIGURE 2.57 With a Vibrance adjustment layer and clipping mask. The Vibrance adjustment is now only visible in the sky.

How else could we use this technique?

Let's use the same technique to add a reflection in pair of glasses.

1. With the **john.jpg** file open in Photoshop, grab the Quick Selection Tool (W) and make a selection of the glass lenses (**Figure 2.58**).

FIGURE 2.58

2. Go to *File > Open,* navigate to the **london.jpg** file, and click OK. Go to *Select > All,* followed by *Edit > Copy,* and then click on the john.jpg tab at the top of the screen to go back to the image of John with his glasses.

3. With the selection of the lenses still active, go to *Edit > Paste Special > Paste Into* (**Figure 2.59**) to tell Photoshop to paste the london.jpg file into the selected area (**Figure 2.60**).

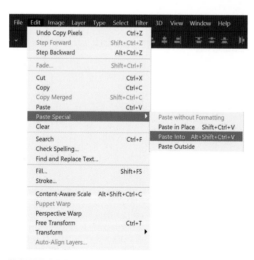

FIGURE 2.59

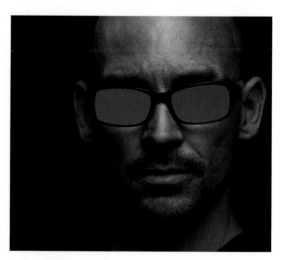

FIGURE 2.60

4. In the Layers panel you can see that a new layer with a layer mask has been added to the image (**Figure 2.61**). The white areas of the mask are the areas we selected (the lenses), which restrict where we can see parts of the london.jpg layer. The area of the layer mask outside of the selection is covered in black, meaning it is concealing the london.jpg file from that part of the picture.

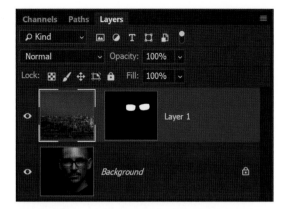

FIGURE 2.61

5. Notice that there is no chain icon between the thumbnails of London and the layer mask. This means you can click on the London thumbnail, and then use the Move Tool (V) to drag the image around the workspace and reposition it so that the view of the skyline is visible in the lenses (**Figure 2.62**).

6. Let's finish this off by matching the colors between the john.jpg and london.jpg files. Click on the Background layer (john.jpg) in the layers stack and hold down Ctrl + J (PC) or Command + J (Mac) key + J to create a duplicate of the layer. Drag this layer to the top of the layer stack.

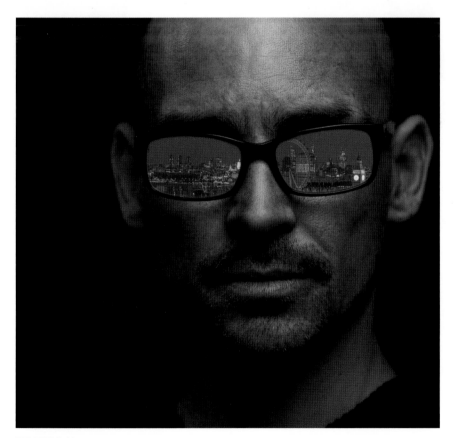

FIGURE 2.62

7. Go to *Filter > Blur > Average.* This command turns the layer into a color that is a mix of everything on it. Double-click on the layer name and rename it color (**Figure 2.63**). Now open the blend modes drop-down menu, which is the second menu from the top on the left side of the Layers panel, and select Color (**Figure 2.64**). (We'll cover blend modes in more detail in chapter 4.)

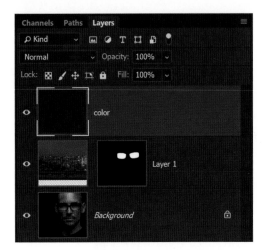

FIGURE 2.63

FIGURE 2.64

8. The color has been applied to the entire picture, but we want it to be visible only on the visible parts of the layer below (i.e., the lenses). Just like what we went through with the statue image earlier, we need to add a clipping mask, but this time there isn't an icon to click on. In this case, you can either go to *Layer > Create Clipping Mask* (**Figure 2.65**), or position the cursor between the color layer and the layer below, and hold down Alt (PC) or Option (Mac) as you click your mouse. Once again, you'll see that little right-angled arrow to the left of the color thumbnail, indicating a clipping mask has been applied (**Figure 2.66**).

FIGURE 2.65

9. Finally, lower the Opacity of the color layer to around 50% so that the London scene in the lenses more closely matches the color in the rest of the portrait (**Figure 2.67**).

FIGURE 2.66

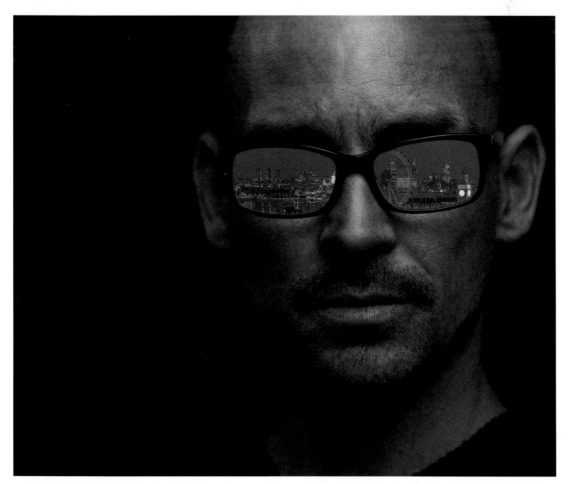

FIGURE 2.67

ADJUSTMENT LAYERS

Moving on, let's take a look at adjustment layers. By default, you'll find them in the Adjustments panel on the right side of the Photoshop workspace, above the Layers panel (**Figure 2.68**). If you don't see the Adjustments panel, go to *Window > Adjustments* to open it.

The available adjustment layers are as follows (from top-left to bottom-right):

• Brightness/Contrast

• Levels

• Curves

• Exposure

• Vibrance

• Hue/Saturation

• Color Balance

• Black & White

• Photo Filter

• Channel Mixer

• Color Lookup

• Invert

• Posterize

• Threshold

• Selective Color

• Gradient Map

What do adjustment layers do? Well, they're layers that you can use to make adjustments to your pictures.

Now don't get me wrong; I'm not just trying to be funny by saying that. You see, you can access the exact same adjustments via the *Image > Adjustments* menu (**Figure 2.69**), but there is a BIG difference. Let me explain.

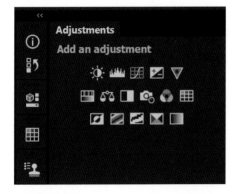

FIGURE 2.68

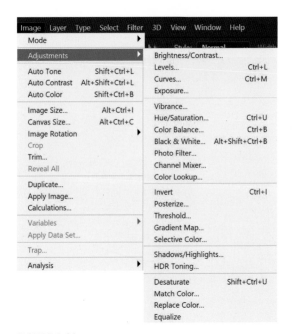

FIGURE 2.69

As an example, I'll use a picture of my life-long friend Nathan Black (**Figure 2.70**). Let's say that I want to add some warmth to the picture. Of course, there are lots of ways I could do this, but for this example I'm going to use a simple adjustment in Photoshop: the Photo Filter.

I'll start by going to *Image > Adjustments > Photo Filter.* In the Photo Filter dialog, I'm going to choose the Warming Filter (85) from the Filter drop-down menu, increase the Density (strength) to 80%, and click OK (**Figure 2.71**).

The adjustment I've made is way over the top, so what if I want to reduce the strength of the filter I've applied? As long as I haven't touched anything else or made any other

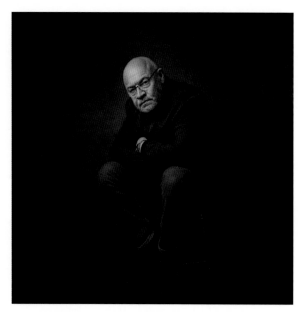

FIGURE 2.70

adjustments I can go to *Edit > Fade Photo Filter,* and then use the Opacity slider to fine-tune it (**Figure 2.72**), but that's quite limiting.

What if I want to increase the strength of the adjustment (the Fade command can only reduce the strength)? What if I want to choose a different Photo Filter? Because the adjustment has been applied directly onto the picture, there's not much else I can do. This is why, in my opinion, it's always best to use adjustment layers as opposed to applying Adjustments via the Image menu.

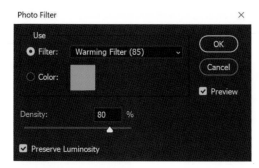

FIGURE 2.71

FIGURE 2.72

Using the same scenario, I'm going to warm up the picture of my friend Nathan Black by using an adjustment layer.

Working with the original image, I'll click on the Photo Filter icon (looks like a little camera) to add an adjustment layer (**Figure 2.73**). In the Properties panel, I'll choose Warming Filter (85) from the Filter menu and increase the Density (strength) to 80% (**Figure 2.74**). In the Layers panel you can see that the adjustment has been added as a new layer with a layer mask attached (**Figure 2.75**).

This adjustment has warmed up the picture of Nathan just as before, but now I can make changes to it; or if I save the file with all the layers intact (as a .psd or .tiff), I can make changes later on.

All I need to do is click on the adjustment in the Layers panel (**Figure 2.76**) to open its Properties, and then I can dial down the Density slider to a different value, choose another Photo Filter, and so on.

In the simplest terms, using adjustment layers gives you flexibility and options at the time of editing or at a later date.

FIGURE 2.73

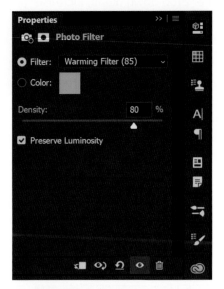

FIGURE 2.74

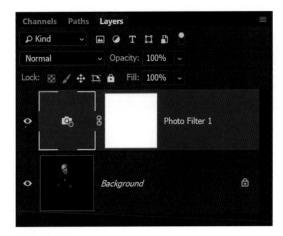

FIGURE 2.75

FIGURE 2.76

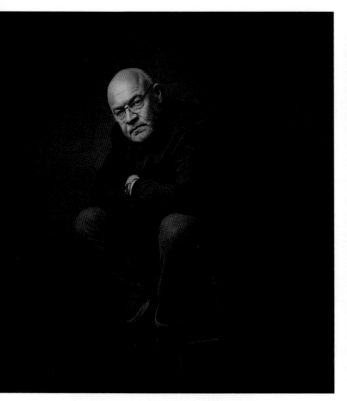

FIGURE 2.77 Photo Filter at 80% Density

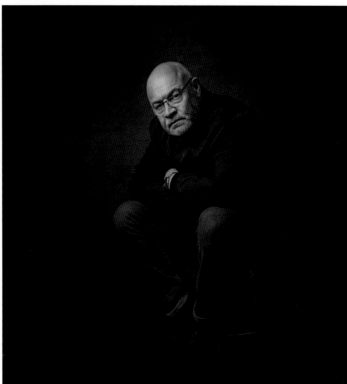

FIGURE 2.78 Photo Filter at 40% Density, which to me looks A LOT better

So what about that layer mask?

By default, when you add an adjustment layer, a layer mask will be attached. This is a regular layer mask that behaves exactly as if you had manually added a layer mask.

Let's walk through an example. We'll use a Hue/Saturation adjustment layer to change the color of my friend Julian Stumm's clothing (**Figure 2.79**).

FIGURE 2.79

1. With the **julian.jpg** file open in Photoshop, click on the Hue/Saturation icon to add an adjustment layer (**Figure 2.80**).

2. In the Hue/Saturation Properties, choose Magentas from the Master menu (**Figure 2.81**). We could have chosen any of the colors here, to be honest, but it doesn't hurt to choose the one closest to what we want.

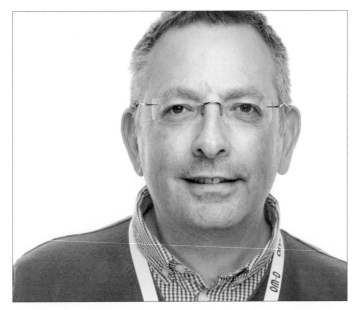

FIGURE 2.80

FIGURE 2.81

At the bottom of the Hue/Saturation Properties panel, you'll notice that there are now some markers positioned along a multicolored bar (**Figure 2.82**). This colored bar is basically a color wheel that has been stretched out, and the markers indicate the colors that you will be affecting now that you have chosen Magentas from the Masters drop-down menu. There are four markers in total—two in the middle and two outside of them. The space between the two middle markers represents the main colors you'll be affecting. The markers on the outside are where Photoshop is being kind and saying, "I'll also let you have some of these colors, too, just in case you need them." This is all well and good, but how do we know that the colors Photoshop is giving us are indeed the ones we want?

Well, we could do this:

FIGURE 2.82

3. Click on the outside markers and drag them inward so that all four are closely bunched up together (**Figure 2.83**), and then click on the Add to Sample icon (the dropper with the plus sign above the color bar).

4. Click and drag over Julian's clothing and notice how the markers we initially bunched up close together have now moved apart (**Figure 2.84**). The area between them represents the colors that we are clicking and dragging over.

5. Drag the Hue Slider (**Figure 2.85**) left or right to change the color of Julian's clothing (**Figures 2.86–2.88**).

FIGURE 2.83

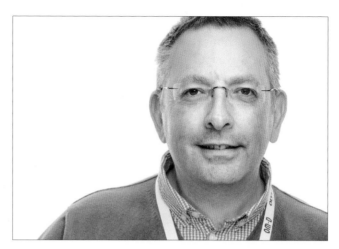

FIGURE 2.86

FIGURE 2.84

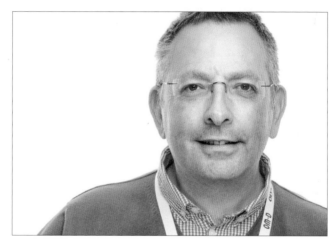

FIGURE 2.87

FIGURE 2.85

FIGURE 2.88

6. If you found that by moving the Hue slider you affected colors elsewhere that you didn't want to, you can simply choose a simple round brush with a black foreground color and paint on the layer mask to hide (conceal) the adjustment in those areas. For example, if I didn't want to change the color of Julian's shirt, I would make sure the layer mask attached to the Hue/Saturation adjustment was active with the frame around it (**Figure 2.89**), and then use the black brush to paint over the shirt (**Figure 2.90**). If I painted away too much, I would simply change the color of the brush (foreground color) to white and paint over that area to reveal it again. Easy, huh?

 TIP *When altering the color of Julian's clothing with the Hue slider, try experimenting with the Saturation and Lightness sliders, too, to see what other results you can achieve.*

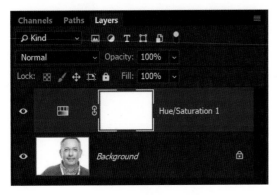

FIGURE 2.89

FIGURE 2.90

There's a reason your computer will love you for using adjustment layers, and that's file size.

For example, let's say you made the previous adjustment to Julian's clothing, but instead of using an adjustment layer you used an adjustment from the Image menu. Remembering that the adjustments from the Image menu are applied directly to the picture, in an effort to work smarter you duplicated the Background layer and applied the adjustment to the new layer instead. The problem here is that when you duplicate the layer, you increase the file size, and the larger the file becomes the more strain it puts on your computer.

Using adjustment layers instead causes only a negligible, if any, increase in file size!

ADJUSTMENT LAYERS, MASKS, AND SELECTIONS

When you have an active selection and then add an adjustment layer, the adjustment is only visible in the selected area. Let me show you what I mean.

Here we have a picture of one of my closest friends, Brian Dukes (**Figure 2.91**). Let's say we want to change the color of his eyes to blue.

FIGURE 2.91

1. Open the **brian.jpg** file and make a selection around Brian's eyes. You can use whichever technique you like, but I'm going to use the Elliptical Marquee Tool (**Figure 2.92**).

> **NOTE** When you're using the Elliptical Marquee Tool, holding down the Shift key ensures a perfectly round ellipse. You can then use the Shift key to add another selection around the other eye; however, holding down the Shift key won't retain the shape of a perfectly round ellipse the second time, so you'll need to judge it by eye. Holding down the Shift key and space bar will allow you to reposition this additional selection.

2. With the active selection around Brian's eyes, add a Hue/Saturation adjustment layer. When you add the adjustment layer, you'll notice that the active selection disappears, but when you look at the layer mask attached to the Hue/Saturation adjustment layer in the Layers panel, the area that was selected is white and everything else is black (**Figure 2.93**). In layer mask terms, this means that any adjustments you make will be visible only in the white areas (eyes) and not anywhere else (black).

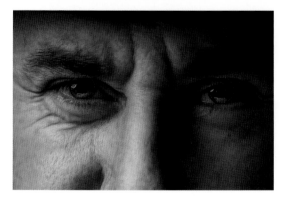

FIGURE 2.92

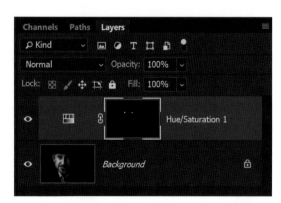

FIGURE 2.93

3. In the Properties panel, click on the Colorize checkbox to insert a check mark, and then drag the Hue/Saturation slider left and right to alter the color of Brian's eyes. In my example, I set the Hue to 203 and reduced the Saturation to 25 so that the color change was much more subtle (**Figure 2.94**).

Looking at the adjustment, you can see that the outline is extremely defined, which makes it obvious that we made an adjustment. We need to soften this down. This is often called feathering. The tricky part with feathering is knowing how much to apply, so here's a way to get around that using the layer mask:

4. Zoom into the eyes. Hold down the Alt (PC) or Option (Mac) key and click on the layer mask attached to the Hue/Saturation adjustment layer. This shows you the layer mask in black and white in the main workspace. Notice how the white circles have a defined outline. To soften this so that the adjustment doesn't look so obvious and blends in much more convincingly, go to *Filter > Blur > Gaussian Blur*. Set the Radius to about 3 Pixels and click OK (**Figure 2.95**).

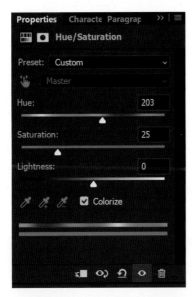

FIGURE 2.94

FIGURE 2.95

FIGURE 2.96 Before applying Gaussian Blur

FIGURE 2.97 After Gaussian Blur has been applied

5. Hold down the Alt (PC) or Option (Mac) key and click on the layer mask to go to back to the normal view. With a normal round brush and black foreground color, paint over any excess area that was originally selected (e.g., portions of the eyelids) to hide the adjustment from that area.

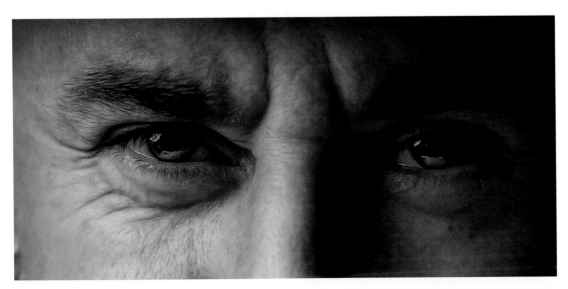

FIGURE 2.98 Before

FIGURE 2.99 After

LAYER MASKS AND GROUPS

So far we've looked at the benefits of applying layer masks to a layer, but they can also be attached to layer groups, which gives us even more control. Let's walk through an example.

FIGURE 2.100 Wedding photographer, friend, and top fella Paul Callaghan

FIGURE 2.101

Figure 2.101 shows a portrait of my friend Paul that I've been working on, and I'm now at the stage where I want to colorize the picture to give it a distinctive look and feel. I could do this in a number of ways, but currently, my preferred method for colorizing my pictures is to use a mixture of adjustment layers, including Color Lookup Table (LUT) adjustment layers (**Figure 2.102**). Check this out:

FIGURE 2.102

1. Open the **paul.jpg** file in Photoshop. Click on the Color Lookup icon in the Adjustments panel to add an adjustment layer. In the Properties panel, click on the 3DLUT File drop-down menu and select TensionGreen.3DL (**Figure 2.103**).

 In the Layers panel, lower the Opacity of this adjustment layer to around 30% (obviously these settings are according to my own taste; you can set them to whatever you prefer).

2. Add a second Color Lookup adjustment layer, and this time choose EdgyAmber.3DL from the 3DLUT File menu. Lower the Opacity of this adjustment layer to 20%.

3. Add a third Color Lookup adjustment layer, choose FoggyNight.3DL, and lower the Opacity of this layer to 20%.

4. Set the foreground and background colors to their defaults of black and white by pressing D on your keyboard. Then click on the Gradient Map icon in the Adjustments panel to add an adjustment layer (**Figure 2.104**). This gives us a pretty nice black-and-white image straight out of the bag (**Figure 2.105**); however, in this case I want to use it to desaturate the image slightly, so reduce the Opacity of the layer to 20%.

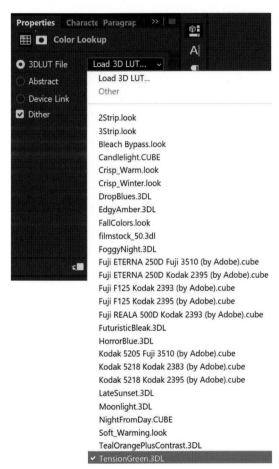

FIGURE 2.103

FIGURE 2.104

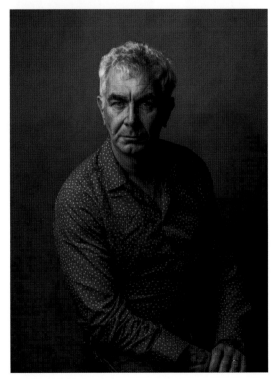

FIGURE 2.105

5. I'm loving how all the adjustments we've just added (**Figure 2.106**) change the overall mood of the image; however, I'm not so keen on how the adjustments have affected Paul's skin, so I want to reduce the effects a little in that area. First, let's organize the adjustment layers into a group. Click on the uppermost layer, then while holding down the Shift key, click on the first adjustment layer. This will highlight all of the adjustment layers in the layer stack (**Figure 2.107**). Now go to *Layer > New > Group from Layers*. (You could also click on the Layers panel menu icon in the top-right corner of the panel and select New Group from Layers.) Name this Group **color** and click OK (**Figure 2.108**).

FIGURE 2.106

FIGURE 2.107

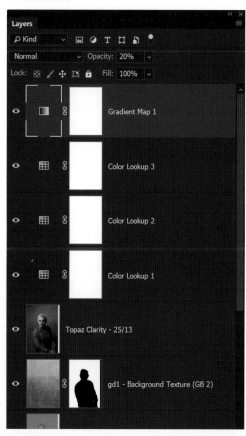

FIGURE 2.108

6. Add a layer mask to this group by clicking on the Add Layer Mask icon at the bottom of the Layers panel (**Figure 2.109**).

You might be inclined to think that all we need to do to reduce the colorizing on Paul's face is to paint with a black brush on the layer mask attached to the group, and you'd be kind of right, but also kind of wrong. Let me explain.

Let's say you want to reduce the colorizing effect by 50%. You choose a simple round brush with a black foreground color, set the Opacity of the brush to 50%, and begin painting the effect away. The problem here is that if you lift off and then continue brushing again, there's a high possibility that you will go over areas again, building up the opacity and, in turn, reducing the colorizing more in some areas than others.

FIGURE 2.109

You can see this in the layer mask view shown in **Figure 2.110**, where I have tried to reduce the effect by brushing with a lower opacity. Different shades of gray means the colorizing from the adjustment layers is showing through in different amounts across Paul's face.

So how can we do this better? Well, there's actually a slider we can use with layer masks that makes this so much easier, and it's called Density. You'll find the Density slider in the layer mask Properties when you click on the layer mask and make it active (**Figure 2.111**).

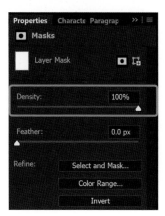

FIGURE 2.110

FIGURE 2.111

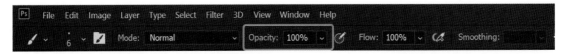

FIGURE 2.112

7. Make sure the layer mask attached to the color group is active, and then choose a round brush with a black foreground color and set the Opacity to 100% (**Figure 2.112**). Paint over Paul's skin and hair to conceal (hide) the colorizing effect completely from this area. Now drag the Density slider down to 50% (**Figure 2.113**). You'll notice that when you do this the colorizing effect on Paul's face and hair is reduced.

Think of the Density slider as the Blacks slider. To reduce the black on the layer mask, drag the Density slider to the left; to increase the black, drag the Density slider to the right. Obviously you can't make black blacker, but you get what I mean, right?

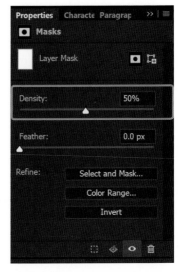

FIGURE 2.113

FIGURE 2.114 Before Density slider

FIGURE 2.115 After Density slider

LAYER MASKS AND GRADIENTS

Up to this point we've looked at how painting in black or white on a layer mask affects the visibility of a layer (i.e., black conceals [hides] what is on a layer and so reveals the contents of the layer[s] below, and white reveals [shows] the contents of a layer). However, in the previous section we put the Density slider to use and discussed how we can use different shades of gray to control the visibility or opacity of what is on a layer. Now let's take a look at how we can use that information.

Let's start by looking at a typical black-to-white gradient (**Figure 2.116**). On the far left we see pure black, and on the far right we see pure white. In between there is a gradual transition from black to white with varying shades of gray.

For this section, we'll use the image of the supercar shown in **Figures 2.117** and **2.118** as an example. I photographed the car outside on a old airfield, and then in Photoshop I retouched the image, cut the car out of the original background, and added a white background.

FIGURE 2.116

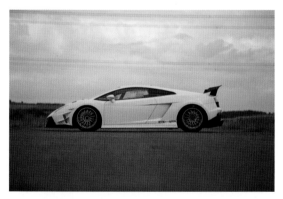

FIGURE 2.117 Before

FIGURE 2.118 After

Now let's add a reflection so that it looks like the car is in a white studio with a very shiny floor. To do this I've saved the original selection used to cut the car out of the background.

1. Open **supercar.psd** in Photoshop. Go to *Select > Load Selection* and from the Channel menu, choose car cut out (**Figure 2.119**), and then click OK.

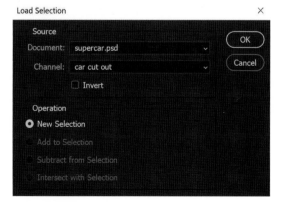

FIGURE 2.119

2. With the active selection now around the supercar, press Ctrl + J (PC) or Command + J (Mac) key to place a copy of the car (selection) onto a new layer. Rename this layer **reflection**, and then click on the Add Layer Mask icon at the bottom of the Layers panel (**Figure 2.120**).

3. Go to *Edit > Transform > Flip Vertical*. Select the Move Tool (V) and while holding down the Shift key, click and drag the upturned supercar to position it underneath the original (**Figure 2.121**).

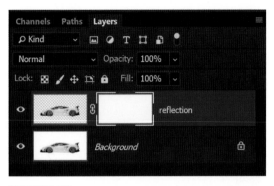

FIGURE 2.120

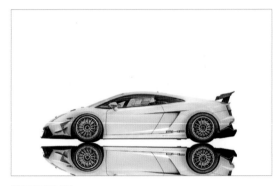

FIGURE 2.121

Now you might think that simply lowering the opacity of the reflection layer would be enough to fake the reflection, and I guess you could get away with this, but it's the small things in retouching that make the big difference. Instead of opacity, let's use a gradient to fade out the reflection as it gets further away from the car, as would be the case in real life.

4. Press D on the keyboard to set the foreground and background colors to their defaults of black and white. If your foreground color is black and your background color is white, press X to swap them. Now choose the Gradient Tool (G) (**Figure 2.122**), and then open the Gradient Picker in the options bar at the top of the screen and select the first Gradient (Foreground to Background; **Figure 2.123**).

5. Make sure that the layer mask attached to the reflection layer is active (has the frame around it), and then click and drag from the bottom of the door on the original supercar image to the bottom of the picture (**Figure 2.124**).

FIGURE 2.122

FIGURE 2.123

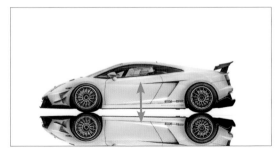

FIGURE 2.124

The gradient this has created on the reflection layer starts with pure white, transitions through varying shades of gray, and eventually turns black as it goes beyond the edge of the picture. The result of this is that the reflection is visible in the white areas and gradually begins to fade away, just as it would in real life (**Figure 2.125**).

 TIP *When you're using layer masks and want to use more than one gradient, choose the Foreground to Transparent Gradient (**Figure 2.126**). If you try to use the Foreground to Background Gradient, you'll find that it only permits you to apply one gradient onto the layer mask; each time you try to add another it simply replaces the previous one you applied as opposed to adding to it.*

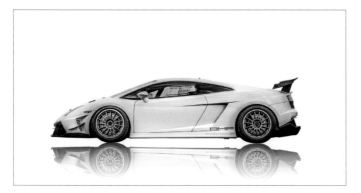

FIGURE 2.125

FIGURE 2.126

Before we move on we need to fix the windows because they still contain the blue reflection of the sky from when the car was originally photographed outside. We can fix this using the same Hue/Saturation technique we used to change the color of Julian's clothing earlier in this chapter...remember?

6. Click on the Background layer and add a Hue/Saturation adjustment layer (**Figure 2.127**).

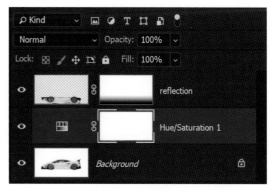

FIGURE 2.127

7. In the Properties panel, choose Blues from the Master menu and drag the four markers on the colored bar together. Click on the Add to Sample tool (the little dropper with the plus sign above the colored bar), and then click and drag over the windows of the supercar to tell Photoshop which blues to alter. Finally, drag the Saturation slider in the Hue/Saturation Properties to -100 (**Figure 2.128**).

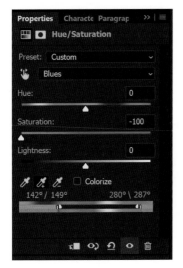

FIGURE 2.128

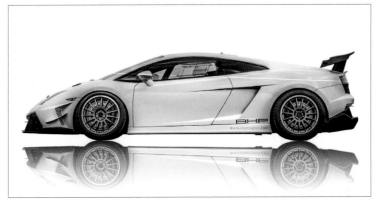

FIGURE 2.129 Before: You can see the reflection of the blue sky in the windows.

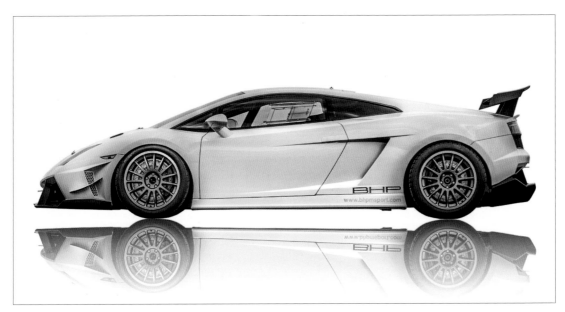

FIGURE 2.130 After: There is no more blue sky in the windows, which adds to the realism of the final picture.

SELECTIONS AND CUTOUTS

If you find yourself regularly making selections and cutouts, then using layer masks is a MUST!

In this section I'll take you through some of the techniques I use the most. These techniques save me so much time and heartache by helping me to get the very best selection quickly and easily, and with minimal fuss.

First let's take a look at a different kind of mask in Photoshop: Quick Mask Mode.

Quick Mask

Although Quick Mask Mode is generally considered something used by beginners, it is incredibly powerful and, what's more, easy to use. Let's work our way through an example so you can see for yourself.

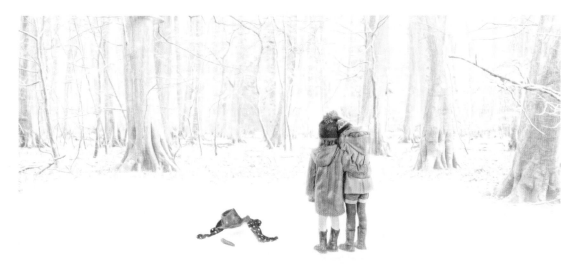

FIGURE 2.131

Figure 2.131 shows the original photograph of the two girls that appear in the snowy scene at the beginning of this section. The first step in creating the snowy image was to make a selection around the girls so I could cut them out of the original background. Here's a quick and easy way to do that:

FIGURE 2.132

1. Open **girls.psd** in Photoshop. Choose the Quick Selection Tool (W) and click and drag over the two girls (**Figure 2.132**).

NOTE *When using the Quick Selection Tool, if you find that it is selecting areas you do not want within the selection, hold down the Alt (PC) or Option (Mac) key and drag over that area to remove it from the selection. Don't spend too much time on this, though, because as you'll see, using Quick Mask Mode can be much quicker at times.*

2. Once you have made a selection, check to see if there are areas that were missed or areas that were included that you didn't want to include. The easiest way to do this is to enter Quick Mask Mode by pressing Q on the keyboard or clicking on the Quick Mask Mode icon at the bottom of the toolbar (**Figure 2.133**). When you do this, you'll notice that the picture is covered with a red overlay, but the area inside the selection is not (**Figure 2.134**). This is a great way to see what is and isn't selected—the red areas represent what isn't selected.

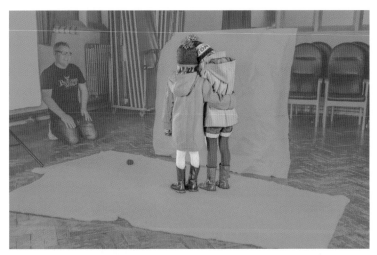

FIGURE 2.133 FIGURE 2.134

Now you can use a simple round brush with either a white or black foreground color to add to or take away from the selection. As you paint in white, you'll see that it removes the overlay so the area becomes part of the selection; when you paint in black, it adds to the red overlay so the area is not included in the selection (**Figures 2.135** and **2.136**).

FIGURE 2.135 Some of the original background has been included in the selection.

FIGURE 2.136 Painting with black in Quick Mask Mode has allowed me to removed that area quickly and easily.

3. Once you have checked the selection in Quick Mask Mode, press Q (or click on the Quick Mask Mode icon in the toolbar) to exit and return to the regular view with the active marching ants selection.

4. With the selection active, you can now go into Select and Mask (or Refine Edge if you're using an earlier version of Photoshop) and finesse the selection. To do this, press W on the keyboard and then click on Select and Mask in the options bar at the top of the screen (**Figure 2.137**).

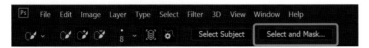

FIGURE 2.137

5. In the Select and Mask Properties, you can use such tools as the Refine Edge Brush and adjust sliders to finesse the selection (**Figure 2.138**). (See the lesson in the section titled Layer Masks with Selections for more information about the Select and Mask tools.)

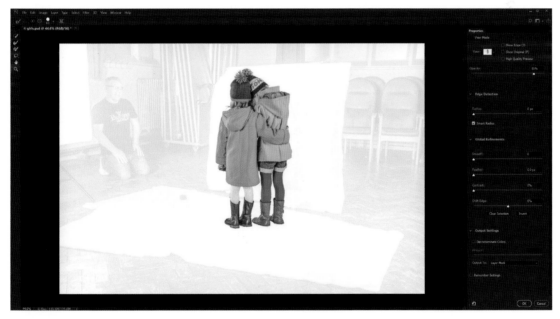

FIGURE 2.138

6. Most importantly, when you are finished, you'll want to open the image back in Photoshop with a layer mask attached. To do so, choose Layer Mask from the Output To menu at the bottom of the Select and Mask Properties panel and click OK (**Figure 2.139**).

You may be asking why, when we've gone through this process of first using Quick Mask and then Select and Mask to make the selection as good as possible, would we need to use a layer mask? Well, because you never know, and it's better to be safe than sorry, right?

In this example, I'm sure glad I output the image from Select and Mask with a layer mask attached because I missed a bit (**Figure 2.140**). Thankfully, having the layer mask means it's an easy fix. After ensuring the layer mask is active in the layers panel (has the frame around it), I can select a brush with a black foreground color and brush over the area on the picture to conceal (hide) it from the selected area (**Figure 2.141**). Now that's easy, right?!

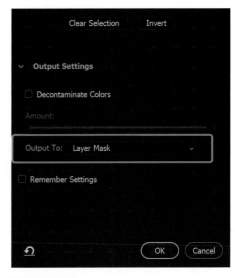

FIGURE 2.139

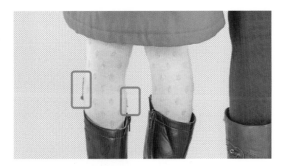

FIGURE 2.140 Darn it...missed a bit!

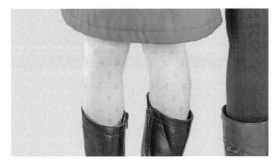

FIGURE 2.141 Easily fixed with a layer mask and a black brush

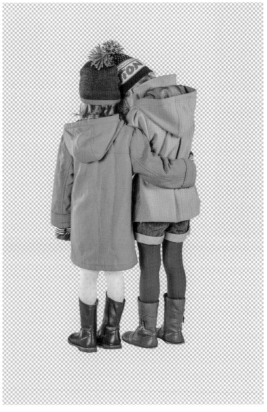

FIGURE 2.142 Final cut out ready for compositing into the new snow scene

Selections and Layer Masks - Removing Halos

I'm guessing that if you have some experience making selections and cutouts, then at some point you have experienced those annoying halos where you can see an outline around your subject (the outline being the original background; **Figure 2.144**).

You could remedy this by adding a layer mask and painting very carefully around the entire cutout with a black brush, but that would take forever and painting with a small brush tip never looks good—I always find it looks jagged.

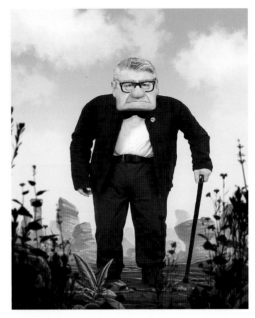

FIGURE 2.143

FIGURE 2.144

Here is a super fast technique that will remove the halos in no time:

1. With the **dave.psd** file open in Photoshop, you can either make a selection yourself or load in the one that I have already prepared for you. To do this, go to *Select > Load Selection* and from the Channel menu in the Load Selection dialog, choose cut out and click OK (**Figure 2.145**). This will now load the selection around the subject.

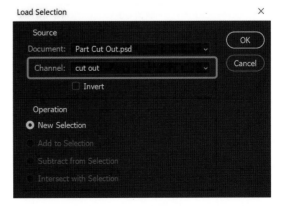

FIGURE 2.145

Actually at this point I think I'd better mention that this is a picture of my best friend, Dave Clayton (**Figure 2.146**), for an *UP*-inspired picture we created back in 2016 with another one of our great friends, Aaron Blaise. Aaron drew the background scene using brushes in Photoshop.

2. Now with the active selection around Dave, click on the Add Layer Mask icon at the bottom of the Layers panel to cut him from the background. (Really this just hides the background around him by using black on the layer mask.)

3. Hold down the Ctrl (PC) or Command (Mac) key and click on the Add New Layer icon at the bottom of the Layers panel. This will add the new layer, but position it below Dave in the Layers panel—a handy shortcut that saves you from having to add the layer and then manually drag it down in the Layers panel. Go to *Edit > Fill*, choose Black from the Contents menu, and click OK (**Figure 2.147**).

NOTE *The black layer beneath Dave just allows us to see the halos clearer for the purposes of going through this technique.*

4. Click on the layer mask attached to the layer that contains Dave to make it active, and then use the Lasso Tool to draw a loose selection around the outside of Dave (**Figure 2.148**). Don't include his head because the hair looks great and does not have a halo around it.

5. With the selection visible and the layer mask active, go to *Edit > Blur > Gaussian Blur*. Dial in a Radius of 1 Pixel and click OK (**Figure 2.149**). This adds a small amount of blur directly onto the layer mask. This step is vital because it will help blend the black and white parts of the layer mask together. Without it, the outline will be VERY obvious after the next step.

FIGURE 2.146 Dave doing his best UP impression prior to the Photoshop treatment

FIGURE 2.147

FIGURE 2.148

Gaussian Blur dialog with OK, Cancel, Preview, 100%, Radius: 1.0 Pixels

FIGURE 2.149

6. Zoom into an area of the picture where you can see the halo, and then go to *Image > Adjustments > Levels*. Drag the black Input Levels slider (**Figure 2.150**) slowly across to the right until the halo disappears (**Figures 2.151** and **2.152**).

So what really happened here? When we drag the black point over in the Levels adjustment, we are simply adding more black, which means we are increasing the size of the black area on the layer mask. As the black area grows it starts to cover the white area of the layer mask (**Figure 2.153**). This means the white area of the mask gets smaller and we see less of the picture of Dave (white reveals, black conceals).

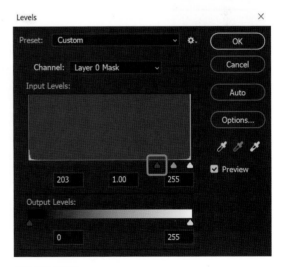

FIGURE 2.150

FIGURE 2.151 Here we can see the halo

FIGURE 2.152 Increasing the blacks in the layer mask hides the halo

FIGURE 2.153

I have a lot more tips, tricks, and techniques I want to share with you, but they go a step further and start to involve both brushes and blend modes, so we'll cover those in the subsequent chapters.

However, I have one last image to share before we move on. This is a portrait of my brother, Liam, who joined me on stage at The Photography Show in Birmingham in March of 2018. Up until this point, Liam had never seen me present on stage, so it was extra special that he not only saw me presenting, but that I actually had him join me on stage wearing an authentic 1940s RAF uniform that I'd rented (**Figure 2.154**).

FIGURE 2.154

So why am I telling you this? Well, the final picture wouldn't have been possible without layer masks because it was made up of two separate pictures. The arm and leg of **Figure 2.155** was replaced with the arm and leg of **Figure 2.156** so that instead of his hand resting on his leg, it looked as though it was behind the hat.

This portrait shows some of the cool stuff that layer masks allow us to do. Right, let's move on and get cracking...

FIGURE 2.155

FIGURE 2.156

Aaron Bl

3

BRUSHES INC.

It sounds crazy when I say this now, but when I first started using Photoshop I didn't think that brushes were for me. Actually, no, let me clarify what I mean. I didn't think anything other than a normal, round, black or white brush was for me because that's all I needed for using layer masks. I thought all the other really clever stuff you can do with brushes was for all those artsy types. How wrong I was!

Whether you're what I would call a traditional artist—someone like my dear friend Aaron Blaise who does the most incredible drawings and paintings—a graphic designer like my buddy Dave Clayton, or a photographer like, well, me, there is definitely a place for brushes in your workflow.

So in this chapter, seeing as how I believe brushes are one of the three areas of Photoshop that everyone needs a grasp on, I thought we'd start by covering brush basics. Then I'll show you how you can make your own brushes and use brushes in ways you may not have thought about before.

Let the fun begin!

BRUSH BASICS

Unsurprisingly, you'll find the Brush Tool in the toolbar on the left side of the Photoshop workspace (**Figure 3.1**). There are other tools within the submenu—namely, the Pencil Tool, Color Replacement Tool, and Mixer Brush Tool—but we won't be looking at those.

As with every tool in Photoshop, when you click on the Brush Tool in the toolbar, the options for that tool are shown in the options bar at the top of the screen (**Figure 3.2**).

Let's take a look at the options bar and discuss each Brush Tool option.

FIGURE 3.1

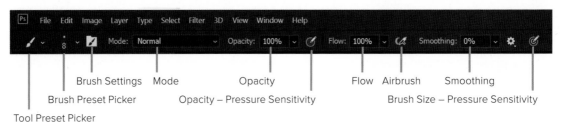

FIGURE 3.2

Tool Preset Picker

The Tool Preset picker is always visible, regardless of what tool is selected, and it allows you to access presets for certain tools quickly. You'll see that there are presets listed, but likely none of them relate to the actual Brush Tool. This is because there is another area where you access brush presets, which we'll cover soon. However, if you remove the check mark from the Current Tool Only checkbox, a number of presets for other tools in Photoshop will be displayed (**Figure 3.3**).

FIGURE 3.3

Brush Preset Picker

This is where you can choose from a wide variety of brushes that are preinstalled in Photoshop, brushes you've downloaded and installed, or even brushes that you've made yourself (**Figure 3.4**).

In the top-left corner of the Brush Preset picker you'll see a circle with a cross hair, two dots and an arrowhead (**Figure 3.5**). You can alter the shape of the brush by clicking on the dots and dragging them inward, and you can rotate it by clicking and dragging on the arrowhead (**Figure 3.6**). You'll see how this can be incredibly useful and creative later.

You can alter the size of the brush in a range from 1px to 5000px by simply dragging the Size slider right or left.

FIGURE 3.4

FIGURE 3.5

FIGURE 3.6

Hardness relates to how hard or soft the brush tip is. A hard brush has a very defined edge (**Figure 3.7**) and a soft brush has an edge that fades out (**Figure 3.8**). The Hardness slider can be adjusted from 0% (maximum softness) to 100% (maximum hardness), and anywhere in between.

FIGURE 3.7 90-pixel brush at 100% Hardness

FIGURE 3.8 90-pixel brush at 0% Hardness

Below the sliders is a bar where you can quickly access any of the last seven brushes you used (**Figure 3.9**).

Clicking on a brush will give you the exact same attributes of the brush you previously used, including its size and any other attributes you set up to make it behave in a certain way.

Below the recently used brushes are all of the brushes that you have installed (**Figure 3.10**). Each one has a number that corresponds to the pixel size of the brush when it was made. Obviously, if you have installed a lot of brushes, then this area can become very full, making it difficult to locate the brush you want to use. Luckily, there are ways to organize and display the brushes to help with this.

FIGURE 3.9

FIGURE 3.10

For example, **Figure 3.11** shows a number of smoke brushes that I made. Rather than having them all mixed up within the other brushes, I can organize them into a group. There are a couple of ways to do this. You can click on the gear icon in the top-right corner of the Brush Preset picker and choose New Brush Group (**Figure 3.12**); or you can click to highlight one of the brushes, hold down the Shift key and highlight the other brushes you would like to include in the group, and then right-click on one of the highlighted brushes and choose New Brush Group (**Figure 3.13**).

FIGURE 3.11

FIGURE 3.12

FIGURE 3.13

Once you have created a group you can close or expand the group by clicking on the arrowhead icon next to the group name (**Figure 3.14**). If at a later stage you want to add a brush to this group, simply click on the brush and drag it into the group. You can also drag a brush out of a group to remove it from the group.

FIGURE 3.14

There is a slider at the bottom of the Brush Preset picker that can be moved right or left to increase or decrease the size of the brush previews (**Figure 3.15**). This doesn't affect the pixel size of the brushes.

FIGURE 3.15

When you click on the gear icon in the top-right corner of the Brush Preset picker a menu opens with a number of options. We'll cover some of these as we work through the examples in this chapter, but while we're on the subject of viewing the brushes, you can also choose to preview the brushes by their Tip, Stroke (shape), Name, or a combination of each (**Figure 3.16**).

FIGURE 3.16

Let's head back to the options bar at the top of the screen (Figure 3.2).

Brush Settings

Clicking on this opens the Brush Settings panel where we can alter the brush attributes and make it look and behave in an unlimited number of ways. We'll be covering this in more detail later on.

Mode

This is the blend mode menu. We'll cover these modes in a lot more detail in the next chapter.

Opacity

This is where you control the transparency or density of the brush you are using—the lower the Opacity, the less dense the brush is (**Figure 3.17**). If you lower the Opacity and continually brush over an area without lifting off, then the opacity will remain the same. If, however, you lift the cursor off and then press down again and continue to brush over the area, the opacity (density) increases. For example, if the Opacity is set to 10% and you brush over the same area twice, lifting off in between each stroke, the brushstroke will have increased to 20% Opacity.

FIGURE 3.17

 TIP *When using the Brush Tool, you can quickly alter the Opacity of the brush with the numerical keys on the keyboard: 1 = 10%, 2 = 20%, and so on. Pressing 0 returns the brush to 100% Opacity. You can also press numerical keys in quick succession: 2 and 5 = 25%, 3 and 8 = 38%, and so on.*

Opacity - Pressure Sensitivity

If you are using something like a Wacom Graphic Tablet or Cintiq screen, you can use Pressure Sensitivity to control the opacity of the brush. When this option is turned on, the harder you press, the greater the opacity, and vice versa.

Flow

Flow is similar to Opacity except that the density of the brush builds up if you go over the same area without lifting the cursor from the screen. The more you continually brush over an area, the denser the brushstroke becomes.

 TIP *When using the Brush Tool, you can quickly alter the Flow of the brush by using the Shift key and the numerical keys on the keyboard: Shift + 1 = 10%, Shift + 2 = 20%, and so on. Pressing Shift + 0 returns the brush to 100% Flow. You can also press numerical keys in quick succession: Shift + 2 and 5 = 25%, Shift + 3 and 8 = 38%, and so on.*

Airbrush

You can use this to create really cool effects, but basically it does what the name suggests and turns your brush into an airbrush. For example, if you set the Opacity of the brush to 10% and press down with this airbrush option turned on, the density of the brush will continue to increase. This is similar to using Flow, except you don't need to continually move the brush. It's just like pressing down the nozzle on a spray can and keeping it pointed in the same area.

Smoothing

This was a very welcome enhancement! It was never easy to draw a line in Photoshop without it looking uneven and wobbly, but with Smoothing, it's no longer a problem. In **Figure 3.18** I've used a brush to write my name with no Smoothing, and in **Figure 3.19** I've written my name with Smoothing.

FIGURE 3.18 Smoothing off

FIGURE 3.19 Smoothing on at 75%

There are more options available for Smoothing that you can access by clicking on the gear icon next to the Smoothing option in the options bar.

Brush Size - Pressure Sensitivity

When you're using a Wacom Graphics Tablet, Cintiq, or similar, turning this option on allows you to alter the size of the brush by varying the pressure of your pen.

I have a few final shortcuts to mention at this point...

 TIPS

- *Use the left and right square bracket keys [] to alter the size of the brush.*
- *Use the Shift key with the left and right square bracket keys to alter the brush Hardness.*
- *Right-click on the working document to display the Brush Preset picker.*

Now let's look at how we can use all this great stuff to create our own brushes, and go over some practical ways we can use them in our workflow.

BRUSH SETTINGS

The Brush Settings panel is where the magic happens because this is where you can alter settings to control what the brush looks like and how it behaves. This allows you to create all manner of cool effects and custom brushes.

Let's start by modifying one of the preinstalled brushes.

1. Create a new document in Photoshop with the following dimensions: Width – 4000 Pixels, Height – 2500 Pixels, Resolution – 300 Pixels/Inch. Then choose a brush from the Brush Preset picker—let's go for one that's preinstalled in Photoshop called Dune Grass (number 112 in my Brush Preset picker; **Figure 3.20**).

FIGURE 3.20

IMPORTANT If you are using Photoshop CC and you don't see this brush, click on the gear icon in the top-right corner of the Brush Preset picker, select Legacy Brushes from the menu, and click OK in the popup that says "Restore the Legacy Brushes Brush Set to the list of Brush Presets?" (**Figure 3.21**).

FIGURE 3.21

You'll find the Dune Grass brush in the Brush Preset picker inside the Legacy Brushes > Default Brushes folder (**Figure 3.22**).

FIGURE 3.22

2. Press D on the keyboard to set the foreground and background colors in the toolbar to their defaults of black and white. Increase the size of the brush to around 500 pixels, and then apply a single brushstroke across the top of the document (**Figure 3.23**).

FIGURE 3.23

Notice how the individual lines in the brushstroke vary in size, angle, and tone? This is all done in the Brush Settings panel (**Figure 3.24**), which you can access by clicking on the icon in the options bar at the top of the screen (Figure 3.2), or by going to to *Window > Brush Settings*. This panel is definitely where the magic happens!

At the bottom of the Brush Settings panel is a preview of what the brush will look like if you use it with the current settings. If you make changes to any of the settings, you'll see them reflected in this area. For example, if you click on the Shape Dynamics tab and adjust the Angle Jitter, you can see how the angle of the brush randomly rotates (**Figure 3.25**).

FIGURE 3.24

FIGURE 3.25

> **NOTE** *Jitter basically means randomize. The higher the Jitter, the more random and varied the brush will be, depending on what it is you are using Jitter with. For example, Size Jitter varies the size of the brush with every brushstroke. In the Transfer tab, Opacity Jitter varies the Opacity (density) of the brush with each brushstroke. This is invaluable for creating effects such as snow, smoke, debris, etc., so that the brushstroke isn't identical each time, and the effect is much more realistic.*

3. Set the Angle Jitter back to around 5%, then click on the Color Dynamics tab and increase the Hue Jitter to around 5% and the Saturation Jitter to 15% (**Figure 3.26**).

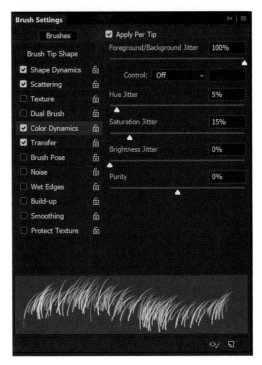

FIGURE 3.26

4. Click on the foreground color in toolbar and choose a shade of green—I went for R: 97, G: 118, B: 83 (**Figure 3.27**). Click OK. Next, click on the background color and choose a different shade of green, such as R: 48, G: 108, B: 52 (**Figure 3.28**), then click OK. Now apply a single brush-stroke across the document (**Figure 3.29**).

Notice how the green varies across the brushstroke in both hue and saturation; again, this is all due to the Brush Settings.

FIGURE 3.27

FIGURE 3.28

FIGURE 3.29

BRUSHES WITH SELECTIONS AND CUTOUTS

No matter how good the tools in Photoshop are, there's never going to be a tool that works equally well on every picture. Selection tools are a perfect example of this. For example, there are some pictures on which the Quick Selection Tool works an absolute treat; however, there are others on which it struggles, and this is when using other tools in our Photoshop Toolbox can really help us out.

A perfect example would be in the picture shown in **Figure 3.30**. Let's say we want to make a selection of the fawn in the middle and cut it out to create a composite. Because the color, tone, and contrast of the fawn is nearly identical to the others around it, we can use brushes to get a better selection and save a lot of time.

FIGURE 3.30

1. Open the **fawn.psd** file in Photoshop and make a selection of the fawn. You can use any tool you like to do this, but to save time I have already made a selection for you. Go to *Select > Load Selection*, choose fawn from the Channel Menu, and click OK.

2. With the active selection now around the fawn, add a layer mask by clicking on the icon at the bottom of the Layers panel to cut the fawn from the background (**Figure 3.31**). (We're really just hiding the background behind the black area of the layer mask.)

FIGURE 3.31

Download all the files you need to follow along step-by-step at: http://rockynook.com/pstoolbox

3. Go to *Layer > New Fill Layer > Solid Color*, name it background, and click OK. Then choose a suitable color that could potentially be the sky in a final picture (although using a Solid Color layer means that you can double-click on it later to change the color if you want). I chose R: 108, G: 126, B: 138 (**Figure 3.32**). Click OK, and then drag this Solid Color layer underneath the fawn layer in the layer stack (**Figure 3.33**).

FIGURE 3.32

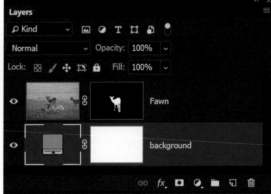

FIGURE 3.33

When we zoom in, we can see that despite using the Quick Selection Tool and a little bit of Refine Edge to pick up some of the fine hairs, there's still some work that needs to be done to improve this selection and cutout. This is something we can do with brushes.

4. Press D on the keyboard to set the foreground and background colors to their defaults of black and white, and then choose a round brush from the Brush Preset picker (**Figure 3.34**) and set the Hardness to 100%.

5. Click on the layer mask attached to the fawn layer so that it is active (has the frame around it), and then use the black brush to paint around the outside of the fawn to remove the areas that don't look very good, where Photoshop hasn't selected the fine hair (**Figure 3.35**).

FIGURE 3.34

FIGURE 3.35

6. Now go back to the Brush Preset picker and choose the preinstalled brushed labeled Grass (**Figure 3.36**) and click to open the Brush Settings.

FIGURE 3.36

NOTE *As mentioned previously, if you don't see this brush in the Brush Preset picker, then you'll need to load the Legacy Brushes. See the note under step 1 in the Brush Settings section for instructions (page 79).*

7. Click on Brush Tip Shape. Set the Spacing to 2%, the Angle to −7, and insert a check mark in the Flip X checkbox (this flips the brush side to side with each brushstroke to vary the look) (**Figure 3.37**).

8. Click on Shape Dynamics and set the Size Jitter to 10% and Angle Jitter to 10% (**Figure 3.38**).

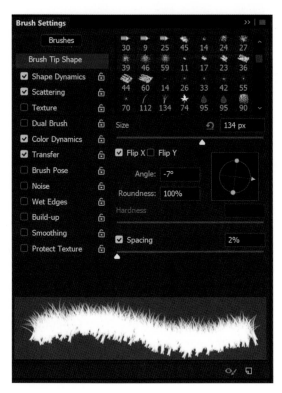

FIGURE 3.37

FIGURE 3.38

9. Click on Scattering and set the Scatter to 40% (**Figure 3.39**). No other attributes in the left-hand column should be checked.

10. Press X to set the foreground color to white, and then start brushing around the outside of the deer to reveal the fur you previously concealed with the black brush. The fur looks much better now because you are revealing it in the shape of the brush, which you made look like fur using some simple brush settings (**Figure 3.40**). Clever, huh?! **Figure 3.41** shows the layer mask—see how the white brush looks like fur?

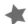 **TIP** *To avoid brushing back too much and revealing the original background, lower the Density of the layer mask to around 50%. This way you'll see the background showing through and can avoid painting over it. When you're finished, set the Density back to 100%.*

FIGURE 3.39

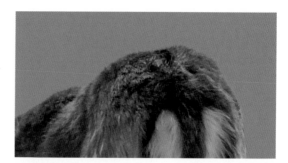

FIGURE 3.40

FIGURE 3.41

This technique has saved me an incredible amount of time and frustration when working with selections and cutouts. Later on we'll look at other brushes that can be used in the same way to cut out hair, and we'll also cover a technique that involves using a brush on a separate layer to fake the cutout by painting in hair. This can look very realistic, especially when you use Color Dynamics to vary the color of the hair just like we did with the grass earlier in this chapter.

YOUR SIGNATURE AS A BRUSH

Now let's look at how to make our own brushes. We'll start by making a brush out of your signature, which can be really useful for signing your pictures before posting them online or printing them.

1. Create a new document in Photoshop with the following attributes: Width – 5000 Pixels, Height – 3500 Pixels, Resolution – 300 Pixels/Inch, Background Contents – White. (The reason I chose 5000 Pixels is because this is the maximum brush size we can create and I think it's best to create the biggest brush you can so that it always looks its best. If you have to increase the size of brush considerably it can start to look pixelated.)

2. Choose a round brush with 100% Hardness and a black foreground color, and then sign your name (**Figure 3.42**).

> **NOTE** *Photoshop can turn anything black into a brush. Any shade of gray leading all the way down to white will also form part of the brush, but will be of varying opacity (density) depending on the tone—i.e., the further from black, the more transparent the brush.*

FIGURE 3.42

3. Go to *Edit > Define Brush Preset* (**Figure 3.43**), give your signature an identifiable name, and click OK. You now have your signature as a brush (**Figure 3.44**) and can access it at any time from the Brush Preset picker (**Figure 3.45**). Brushes you make will appear at the bottom of the Brush Preset picker unless you put them into a group.

FIGURE 3.44

FIGURE 3.43

FIGURE 3.45

Figure 3.46 shows one of my pictures with my signature in the bottom-right corner. In Photoshop I added a new blank layer to the top of the layer stack, chose my signature brush from the Brush Preset picker, selected a white foreground color, and clicked down once on the image to apply my signature. I lowered the opacity of the layer to 50%.

> **NOTE** *You could also create a signature brush by signing a white piece of paper with a black pen and scanning it. Open the scan in Photoshop and go through the steps above.*

FIGURE 3.46

CREATING A SMOKE BRUSH

Knowing that we can create brushes in Photoshop from anything that is black and varying shades of gray, let's look at creating a smoke brush.

1. Open the **smoke.jpg** file in Photoshop. This is a picture I took in my office of a burning joss stick. I attached a piece of black card to my monitor as the background (**Figure 3.47**).

2. Start by using the Crop Tool (C) to crop out the bottom part of the picture so that you're left with only the smoke. Then go *to Image > Adjustments > Desaturate* to remove any color from the picture (**Figure 3.48**).

FIGURE 3.47

FIGURE 3.48

3. For Photoshop to create the smoke brush, the smoke needs to be black, so go to *Image > Adjustments > Invert*. We need to make sure that the area around the smoke is completely white; otherwise, that will form part of the brush as well. Go to *Image > Adjustments > Levels*, select the Set White Point Sample icon (**Figure 3.49**), click on an area of white in the image, and click OK (**Figure 3.50**).

4. Finally, to create the brush go to *Edit > Define Brush Preset*, name the brush (e.g., smoke 1), and click OK. You now have a smoke brush that you can select from the Brush Preset picker (**Figure 3.51**).

FIGURE 3.49

FIGURE 3.50

FIGURE 3.51

NOTE *If the Define Brush Preset option is grayed out in the Edit menu, it is likely because your document size is too large. Go to* Image > Image Size *and check whether it has a Width or Height above 5000. If so, then reduce the dimension to 5000 Pixels and click OK. If you are using an earlier version of Photoshop, Brushes could be a maximum of 2500 Pixels.*

This is the exact same technique I used to add smoke to the unlit cigarette and cigar in the pictures of model Lewis Thompson (**Figure 3.52**) and my mate Dave Clayton (**Figure 3.53**).

FIGURE 3.52

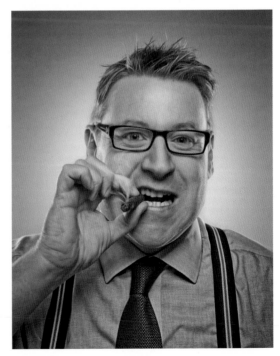

FIGURE 3.53

CREATING A DIRT, DEBRIS, AND SNOW BRUSH

Here's a great way to make a special effect brush to add dirt, debris, or even snow into your pictures—all done using a little bit of soil from your garden.

1. **Figure 3.54** is a photograph I took of a sheet of A4 paper with a small amount of soil that I sprinkled on it. Open this file (**debris.jpg**) in Photoshop and use the Crop Tool (C) to crop out the wooden table (**Figure 3.55**).

FIGURE 3.54

FIGURE 3.55

2. Go to *Image > Adjustments > Desaturate* to remove any color from the picture, and then go to *Image > Adjustments > Levels.* Drag the white point to the left to brighten the white areas and drag the black point toward the right to darken the soil (**Figure 3.56**). Click OK.

3. Now create the brush by going to *Edit > Define Brush Preset,* naming the brush debris (or whatever you like), and clicking OK. If the Define Brush Preset option is grayed out, see the note in the previous section of this chapter.

FIGURE 3.56

4. Now we've created a basic debris brush, but let's take it a step further and adjust the Brush Settings. Start by creating a new blank document around 3000 Pixels by 3000 Pixels at 300 Pixels/Inch with a white background.

5. Open the Brush Settings panel and make the following changes:

Click on Brush Tip Shape and set the Spacing to around 35% (**Figure 3.57**).

Click on Shape Dynamics and set the Size Jitter to 100% and Angle Jitter to 100%, and tick the Flip X Jitter and Flip Y Jitter checkboxes (**Figure 3.58**).

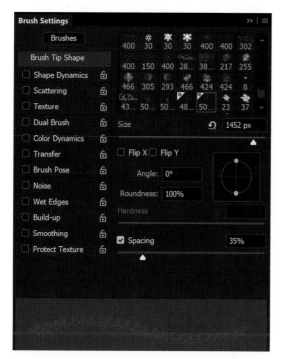

FIGURE 3.57

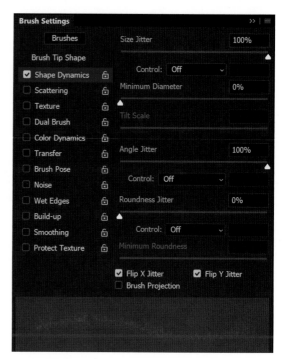

FIGURE 3.58

Click on Scattering, tick the Both Axes checkbox, and increase Scatter to around 120%, Count to 3, and Count Jitter to 50% (**Figure 3.59**).

Click on Transfer and set the Opacity Jitter to 75% (**Figure 3.60**). Finally, ensure that no other options in the left-hand column have check marks.

FIGURE 3.59

FIGURE 3.60

Now we have a debris brush (**Figure 3.61**) that we could also use as a snow brush with maybe a few more tweaks of the Brush Settings (**Figure 3.62**). The settings I've used here are just to show how easy it is to change the attributes and look of the brushes in Photoshop, but I highly recommend you play with these to see what looks you can create.

Having made all these changes in the Brush Settings panel, we wouldn't want to have to repeat these steps every time we use the brush, so we can save the brush along with the settings as a preset.

FIGURE 3.61

FIGURE 3.62

6. Click on the menu icon in the top-right corner of the Brush Settings panel and choose New Brush Preset (**Figure 3.63**). Give the preset a name, such as Debris 1, and then choose whether the preset includes the brush size, all of the settings, and the color. I tend to leave all of these checked (**Figure 3.64**). Once you've made your selections, click OK.

This exact same brush is now available for you to use at any time. Best of all, no matter what colors your foreground and background are, or what brush and settings you are currently using, as soon as you choose this brush from the Brush Preset picker it will be there for you with the exact same settings, colors, and brush size (**Figure 3.65**).

FIGURE 3.63

FIGURE 3.64

FIGURE 3.65

CREATING FUR / HAIR WITH AARON BLAISE

I'd like to offer a huge thanks to my buddy Aaron Blaise (**Figure 3.66**) for contributing to the brushes section of this book with this walk through showing how to create fur and hair.

Aaron is someone who I would think of and refer to as an artist in the traditional sense of the word. By that I mean someone who creates his pictures by starting with a blank canvas and using his talent and skill to create scenes, characters, creatures, portraits, animals, and so on. I believe that as photographers, illustrators, and graphic designers there is so much we can learn from folks like Aaron, from his understanding of light and composition to how he creates his art and does it so quickly, while also making it look so easy—it is completely and utterly mesmerizing (**Figure 3.67**).

Needless to say, I highly recommend you check out Aaron's website (www.creatureartteacher.com), which is packed full of learning materials and resources such as brushes and textures that can be downloaded and installed into Photoshop.

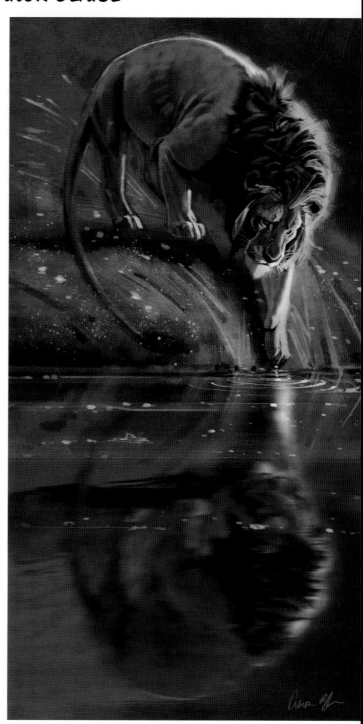

FIGURE 3.67

FIGURE 3.66

Before we go through the steps to create a fur/hair brush, I wanted to let you know that Aaron recorded this process as a video, which is available to you with the downloads for this book. Let's get started.

1. Create a new document in Photoshop with the following dimensions: Width – 5 Inches, Height – 5 Inches, Resolution – 300 Pixels/Inch. Once in Photoshop, set the foreground color to black.

2. In the Brush Preset picker, choose one of the erodible brushes (**Figure 3.68**) and draw a line down the document that fades in and out (**Figure 3.69**).

> ***NOTE*** *If you don't see any of the erodible brushes in the Brush Preset picker, then you'll need to load the Legacy Brushes. See the note under step 1 in the Brush Settings section for instructions (page 79). These erodible brushes are found in the Legacy Brushes > Default Brushes folder.*

3. Now create the brush by going to *Edit > Define Brush Preset*. Name the brush "hair" and click OK.

Clearly, when we use this brush it doesn't look like hair (**Figure 3.70**), so now we have to adjust its settings.

FIGURE 3.68

FIGURE 3.69

FIGURE 3.70

4. Open the Brush Settings panel and click on Brush Tip Shape. Rotate the Angle of the Brush so that it looks like a wave (**Figure 3.71**).

5. Click on Shape Dynamics and underneath Angle Jitter, change the Control menu to Direction (**Figure 3.72**). Now return to the Brush Tip Shape section and adjust the Angle so that the wavy line becomes tighter (**Figure 3.73**).

Now when we paint with the brush, notice how the tip of the brush changes its angle to follow the direction of the brush (**Figure 3.74**). This is very important when creating hair and fur brushes.

FIGURE 3.71

FIGURE 3.72

FIGURE 3.73

FIGURE 3.74

6. To continue making this hair brush, click on Scattering in the Brush Settings panel and increase the Scatter to around 126% and the Count to 1. As you do this, you'll see in the preview area that the brush suddenly starts to look like fur (**Figure 3.75**).

Now if we use the brush we can see that it really is starting to look like hair or fur (**Figure 3.76**).

One thing you may notice, though, is that we get the same look with each brushstroke. We need to make this much more random to look realistic.

FIGURE 3.75

FIGURE 3.76

7. Go back to the Shape Dynamics section and at the bottom of the panel, insert a check mark in the Flip X Jitter and Flip Y Jitter checkboxes. This means that with every brushstroke, the brush will randomly flip left to right and upside down, which will give the hair a much more random and realistic look. Notice how doing this changed the preview (**Figure 3.77**).

Now when we paint with the brush the strokes aren't continually being repeated, but are much more random as they jitter (**Figure 3.78**).

By varying the type of line you create at the beginning of this process and varying the brush settings, you can come up with completely different looks. Let's create another brush, but this time instead of using one line, we'll see what happens if we use multiple lines.

FIGURE 3.77

FIGURE 3.78

8. Create a new document with the same dimensions as before (5 Inches × 5 Inches at 300 Pixels/Inch) and add a new blank layer to the top of the layer stack.

9. Using the same erodible brush, draw out multiple lines (**Figure 3.79**) and then go to *Edit > Free Transform*. Use the Free Transform handles to stretch the lines out to make them longer, and then push in the side to squash them together a little so they almost look like a tuft of fur (**Figure 3.80**).

FIGURE 3.79

FIGURE 3.80

10. We need to fade out the top of this pattern so that the brush blends well later when we increase the number of strokes. Select a white foreground color, increase the size of the brush, and brush across the top of the strokes (**Figure 3.81**).

11. Now go to *Edit > Define Brush Preset,* name the brush "hair 2," and click OK.

12. Open the Brush Settings panel and make the following adjustments:

- Click on Shape Dynamics and under Angle, make sure that Direction is chosen in the Control menu. Put a check mark in the Flip X Jitter checkbox, and then increase the Size Jitter to around 83% (**Figure 3.82**).

FIGURE 3.81

- Click on Scattering and increase the Scatter to around 135% (**Figure 3.83**).

- Click on Brush Tip Shape and set the Spacing to around 9% (**Figure 3.84**).

Figure 3.85 shows what the brushstrokes look like now!

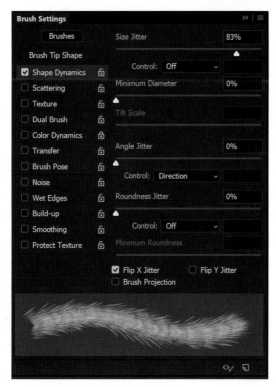

FIGURE 3.82

FIGURE 3.83

FIGURE 3.84

FIGURE 3.85

NOTE *When you watch Aaron's video you'll see that the brushes he makes are different than mine, despite the fact that we used the exact same settings. This is because the initial line(s) we created were different.*

Again, a huge thank you to Aaron for not only putting this tutorial together, but also for creating the video that is available with the download files.

ADDING AND EXPORTING BRUSHES

Before we finish off I want to cover some important menu options that will be useful to you when you're using brushes. In the Brush Preset picker, click on the gear icon in the top-right corner, and you'll see a menu that includes several options that allow you to add brushes to your Brush Preset picker (**Figure 3.86**). You can also export brushes you've created. Let's discuss some of these options.

FIGURE 3.86

How to Import Brushes

This menu option allows you to add more brushes to Photoshop. There's a host of resources across the Internet where you can download free or paid brushes that will give you all manner of different effects, brush styles, and so on. Aaron Blaise has a ton of brushes available on his website: www.creatureartteacher.com.

To add brushes to your Brush Preset picker once you've downloaded them, click on the gear icon in the top-right corner of the Brush Preset picker, choose Import Brushes from the menu, and then navigate to the brushes you want to import. Select the brushes you want and click Load (**Figure 3.87**).

The brushes have now been added to your Brush Preset picker and are available for you to use (**Figure 3.88**).

FIGURE 3.87

FIGURE 3.88

How to Export Selected Brushes

Once you have created some custom brushes, you may want to share them with others. To do this from within the Brush Preset picker, highlight the brushes you want to export (**Figure 3.89**), click on the gear icon in the top-right corner of the Brush Preset picker, and choose Export Selected Brushes.

Navigate to where you want to save the brushes, enter a File name, and click Save (**Figure 3.90**). These files are now available to share with whomever you'd like.

FIGURE 3.89

FIGURE 3.90

Get More Brushes

Choosing this menu option will direct you to an Adobe webpage where there are a number of brushes that have been designed by award-winning illustrator Kyle T. Webster (**Figure 3.91**).

If you subscribe to Adobe Creative Cloud, with this running you can click to download the brushes and they will be automatically added to your Brush Preset picker.

FIGURE 3.91

Restore Default Brushes and Legacy Brushes

The last two menu items I want to briefly mention are Restore Default Brushes and Legacy Brushes.

Restore Default Brushes pretty much does what it says. This is a great way to restore some order in your Brush Preset picker if you find it becoming a little out of control and are struggling to find what you need.

The Legacy Brushes option brings in the many brush presets that have been a part of Photoshop for a long time and were superseded. There are some great Legacy Brushes that are useful for creating effects such as grass or fur, so if you don't have them in your Brush Preset picker, I'd highly recommend you add them.

As I'm sure you can see, making and using brushes can be a whole lot of fun. Even if you're not a traditional artist like Aaron, you can see the massive benefits brushes offer if you use them on layer masks to perfect cutouts, make hair cutouts better by filling in gaps that Photoshop couldn't quite pick up, and so on. And clearly they offer so much more than that.

Whatever you do with them, enjoy!

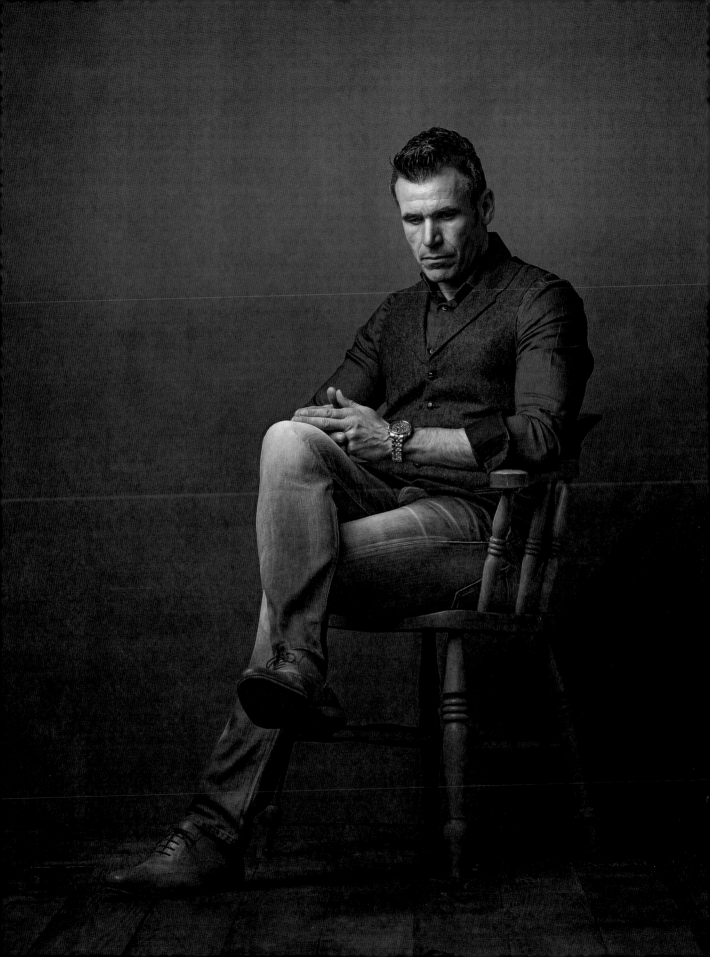

BLEND MODES

If ever something was considered magic in Photoshop it would have to be blend modes. There is so much we can do with these and they are, without a doubt, the fastest way to create special effects. The best results are often achieved purely by experimenting with blend modes. I recommend approaching them with the attitude of "what would happen if...?".

Unless you have an incredibly scientific mind like my friend and digital artist Olaf Giermann from Germany, who totally understands the inner workings of blend modes, don't concern yourself with how they work, but instead work on developing a broad understanding of what you can do with them. Thankfully, blend modes have been organized in such a way that makes this a whole lot easier.

There are 27 blend modes and although they all behave differently from one another, they are organized into six groups (**Figure 4.1**). Some of the following descriptions might sound vague, but we'll go through some examples as we work through this chapter. You'll find that no matter how experienced you become with Photoshop, you'll likely only ever use a portion of the blend modes; it's highly unlikely you'll ever use all 27, but you will have your favorites.

The six blend mode groups are as follows:

- **NORMAL** As the name suggests, when you select Normal, nothing happens to the image. However, Dissolve is a bit of a standalone, and you can create some cool effects with it that we'll cover in a bit.

- **DARKEN** These blend modes will darken the image in their own unique way. It's particularly useful to know that when there is white on the BLEND layer, using the Darken blend mode makes the white areas invisible.

- **LIGHTEN** These blend modes will lighten the image in their own unique way. This is the opposite of the Darken blend mode—if there is black on the BLEND layer, it becomes invisible.

- **CONTRAST** These blend modes will add contrast to the image in their own unique way. Areas that are 50% gray become invisible when they are used on the BLEND layer.

- **COMPARATIVE** These blend modes compare the BLEND and BASE layers to each other and create cancellation or inversion blends—either completely cancelling out or inverting the colors—depending on the content of the BASE layer. You'll see what I mean as we go through them in a little more detail soon.

- **COLOR** These blend modes affect color on the BLEND layer in their own unique way.

FIGURE 4.1 Photoshop blend modes

You'll find blend modes in a number of different places in Photoshop, but the main place you'll find and select them is in the Layers panel (**Figure 4.2**). If there is only a Background layer in the layer stack, then you'll see that the option to change the blend mode is grayed out because you need to have at least two layers (BASE and BLEND) to use a blend mode. If you unlock this single Background layer by clicking once on its padlock icon, the blend modes become available; however, using them will have no impact

FIGURE 4.2

on the single layer in the layer stack. When there is more than one layer in the stack, the blend modes will be available—just click on Normal to open up the menu with the available blend modes.

PUTTING BLEND MODES TO USE

Let's start by taking a look at the effects of each blend mode. For each of the following examples, there is a BASE layer, which is a portrait (**Figure 4.3**), and a BLEND layer, which is a texture (**Figure 4.4**).

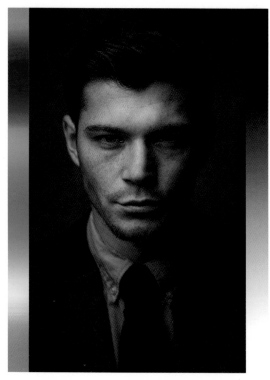

FIGURE 4.3

FIGURE 4.4

We'll apply the blend modes to the BLEND layer in the Layers panel (**Figure 4.5**).

My friend Colin Smith, who runs a superb educational site called PhotoshopCAFE (photoshopcafe. com), produced a cheat sheet for blend modes and he added a color bar and grayscale bar to the BASE layer picture, which really helps to show what is going on. With Colin's permission, I'm stealing that idea and using it here (thanks, Colin).

So, as we change the blend mode of the BLEND layer, here's what happens...

FIGURE 4.5

Normal Blend Modes

NORMAL Nothing happens when you use the Normal blend mode. All you can see is the texture, which is on top of the portrait in the layer stack. To see the layer beneath (BASE), you need to lower the opacity of the BLEND layer. In **Figure 4.6**, I've lowered the Opacity to 50%.

DISSOLVE Dissolve is the same as Normal except that no transparency effects are applied to the pixels. Dissolve dithers pixels on and off—or in other words, granulates the BLEND layer—which creates an almost spray-paint effect that is visible when the Opacity is lowered. In **Figure 4.7**, I again lowered the Opacity of the BLEND layer to 50%. The Dissolve blend mode doesn't actually blend pixels, but simply randomly reveals and conceals areas. If you use this blend mode you'll likely end up using it at a reduced opacity.

Darken Blend Modes

DARKEN All of the Darken blend modes will do just that—darken the layer below with varying degrees of contrast or tone (**Figure 4.8**). If the BLEND layer contains white, then that part of the layer will not affect the BASE because you can't darken with white, right? However, if parts of the BLEND layer are a darker tone than white, then those areas will darken the BASE layer. Again, this is one of the those blend modes that you'll likely use at a reduced opacity.

MULTIPLY The Multiply blend mode can be particularly useful for creating composite images because it combines the contrast and luminosity of both the BLEND and BASE layers. In **Figure 4.9**, the Multiply blend mode has blended the texture of the BLEND layer and has also darkened the BASE layer.

FIGURE 4.6

FIGURE 4.7

FIGURE 4.8

FIGURE 4.9

COLOR BURN As with Multiply, Color Burn darkens both the BLEND and BASE layers, but it creates a much darker image with added contrast and saturation, almost to the point of giving it a burned look. You can see in **Figure 4.10** that the black area of the gradient has turned completely dark, but at around the 50% gray area it looks much nicer. Notice how the white area is untouched.

LINEAR BURN This is another really useful blend mode for getting a great darkening effect. It's kind of similar to the regular Darken blend mode, but it's definitely more subtle. You'll see this blend mode used for creating an aged, vintage-looking effect but again using a lowered opacity on the BLEND layer. Again, no change to white (**Figure 4.11**).

DARKER COLOR To be honest, I don't use this blend mode much, if at all. The result is that the darker colors on the BLEND layer are darkened, as you can see in **Figure 4.12**. Notice how in the white-to-black gradient, the texture above the 50% gray area is blended invisible. You could lower the opacity of this layer to see what results you get, but this isn't a blend mode I tend to use at all.

FIGURE 4.10

FIGURE 4.11

FIGURE 4.12

Lighten Blend Modes

LIGHTEN This does exactly the opposite of the Darken blend mode—only the lightest areas of the BASE and BLEND are visible (**Figure 4.13**). As the name suggests, this blend mode is used to lighten the image, which would explain why black areas of the BLEND are unaffected—you wouldn't use black to lighten, right? Any area brighter than black will affect the BASE to some degree. In the white-to-black gradient you can see that the texture is unaffected in any area darker than around 50% gray.

SCREEN This is the opposite of Multiply. With the Screen blend mode, everything is brightened, with the exception of black on the BASE layer, which remains the same (**Figure 4.14**). If you look at the white-to-black gradient, you can see that pretty much all the way up until black, the texture is brightened and some fade is added. The black area remains unaffected.

I tend to use the Screen blend mode quite often when adding snow or rain effects to a picture, where the BLEND layer is a black-and-white layer with the snow or rain being the white parts. Using the Screen blend mode on a layer like this when its positioned as the BLEND layer (top) means the black disappears and only the white areas are visible. It also fades the image slightly, so lowering the Opacity and using some masking can help.

FIGURE 4.13

FIGURE 4.14

COLOR DODGE This is the opposite of Color Burn. The BASE color is what influences the resulting image, which is brighter and has less contrast (**Figure 4.15**). Again, black remains unaffected.

This is one of my favorite blend modes for creating lighting effects; in particular, very powerful, bright lights of any color. Simply add a blank layer and use a brush to add a few strokes. When you change the blend mode to Color Dodge, you will see the effect to some extent, but you can increase the effect by duplicating the layer multiple times. I love it! Ultimately, when used on an entire layer, the Color Dodge blend mode brightens the image and intensifies the saturation.

LINEAR DODGE (ADD) Linear Dodge is a toned down version of the Color Dodge blend mode. It has a brightening effect, but the colors aren't as intensely saturated, nor is there quite as much contrast (**Figure 4.16**).

I love to use this blend mode when brightening eyes. First I make a selection of the iris, and then I add a Selective Color adjustment layer and change the blend mode to Linear Dodge. Finally, I lower the Opacity of the layer to control the brightness of the eyes. You could use an adjustment layer to do this, but I use a Selective Color adjustment layer because it gives me even more options to alter the color and contrast with the sliders.

FIGURE 4.15

FIGURE 4.16

LIGHTER COLOR This is the opposite of Darker Color. If I'm being honest, I don't recall ever using this blend mode. It's bit more aggressive in how it blends the white areas of the BLEND layer to the BASE layer. Any areas of white up until around 50% gray are heavily blended, while anything

beyond that is basically transparent (**Figure 4.17**). Again, I haven't found a use or need for this blend mode, but hey, you never know.

Contrast Blend Modes

OVERLAY I use Overlay a lot when I'm adding texture to pictures where I've photographed a subject against a gray roll of paper. Anything darker than 50% gray will add contrast to the BASE layer, and anything brighter than 50% gray will brighten and add contrast to the BASE layer (**Figure 4.18**). Yep, I use this one a lot! However, when adding textures, I do tend to desaturate the BLEND layer (texture) beforehand because otherwise the colors can look a little funky.

SOFT LIGHT This is another blend mode that I use a lot. It works pretty much the same as Overlay, except that the result is less contrasty and much more subtle (**Figure 4.19**). Whether you choose Soft Light or Overlay is purely a matter of personal taste.

FIGURE 4.17

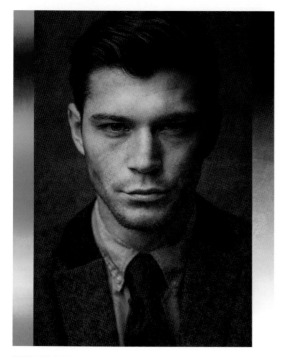

FIGURE 4.18

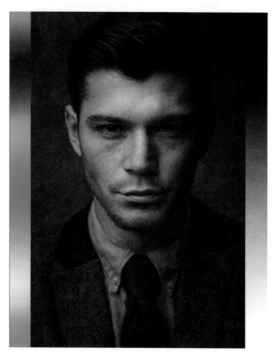

FIGURE 4.19

HARD LIGHT Just based on the name of this blend mode, you know the results are going to be strong, and you'll see this when you give it a try. You'll definitely want to reduce the Opacity of the BLEND layer when you use this. At 100% Opacity, Hard Light keeps the whites completely white and the blacks completely black, but the resulting blend is much less subtle (by a long shot) than Soft Light (**Figure 4.20**).

There's only one technique with which I find myself using this blend mode (at the moment, anyway), and that's when I add fake detail into eyes that don't have any by adding a layer that contains monochromatic (grayscale) noise. There is a video on my YouTube channel showing this technique: http://bit.ly/dewis-hardlight

VIVID LIGHT This is similar to Hard Light except that it uses Color Dodge and Color Burn instead of Screen and Multiply, resulting in much more contrast (**Figure 4.21**).

FIGURE 4.20

FIGURE 4.21

LINEAR LIGHT If the BLEND color is lighter than 50% gray then the result we see is dodged, or the brightness has been increased. If the BLEND color is darker than 50% gray, then the result we see is burned, or the brightness has been reduced (**Figure 4.22**).

PIN LIGHT In areas of the BLEND layer where the colors are 50% gray, the BASE layer will show through; anything else (lighter or darker than 50% gray) will remain visible on the BLEND layer (**Figure 4.23**).

FIGURE 4.22

FIGURE 4.23

HARD MIX This basically results in a posterized image displaying red, green, blue, cyan, magenta, yellow, white, or black—i.e., the primary colors. There are no gradients blending the colors together (**Figure 4.24**).

You can create some really cool looks by using both the Pin Light and Hard Mix blend modes because of the way they remove the smooth transition between colors and create a posterized effect. Admittedly, you get some pretty extreme results with these blend modes. Although I've never found myself using them, I can totally see how they could be used for compositing and adding texture to images.

FIGURE 4.24

Comparative Blend Modes

DIFFERENCE I use this a lot for lining up images. As you'll see later in this chapter in the section called "Lining Up Layers with the Difference Blend Mode," this is a super useful blend mode. It works by subtracting the lighter colors from the darker colors between the BLEND layer and BASE layer. White inverts the BASE layer and black makes no change (**Figure 4.25**).

EXCLUSION This is similar to Difference but with less saturation (**Figure 4.26**).

SUBTRACT This subtracts the BLEND color from the BASE color, resulting in a darker image (**Figure 4.27**). Looking at this image now, I'm liking the effect a lot. Hmmm, might be something to use in a future project!

FIGURE 4.25

FIGURE 4.26

FIGURE 4.27

DIVIDE This divides the BLEND color from the BASE color, resulting in a lighter image (**Figure 4.28**).

Color Blend Modes

HUE This uses the color/hue of the BLEND layer and the saturation and luminosity of the BASE layer (**Figure 4.29**).

SATURATION This uses the color saturation of the BLEND layer and the hue saturation of the BASE layer (**Figure 4.30**).

FIGURE 4.28

FIGURE 4.29

FIGURE 4.30

FIGURE 4.31 FIGURE 4.32

COLOR This uses the color from the BLEND layer and the luminosity and detail from the BASE layer (**Figure 4.31**).

LUMINOSITY All of the detail on the BLEND layer is visible along with the color from the BASE layer (**Figure 4.32**). This is a great blend mode to use, for example, when you're adding contrast to an image using something like a Curves adjustment layer and you notice that doing so also affects the colors by making them more saturated. Using the Luminosity blend mode can help with this by ensuring that the contrast doesn't affect the colors. Of course, you may see a little change in the colors when adding contrast, but the Luminosity blend mode does a great job of helping to reduce that change.

I'm guessing if you're anything like me, now that we've gone through the role of each blend mode, you agree about not needing to know how and why they do what they do, right?

Like I said before, out of all the blend modes, there will be a handful that you regularly turn to in your own workflow with your own images. However, I would advise experimenting and playing around with the blend modes to see what results you can come up with. I often do this just to see if I can come up with something new.

 TIP *To quickly cycle through the blend modes so you can see what they do to an image, press V to select the Move Tool, and then hold down the Shift key while pressing the + or – keys.*

PUTTING THEORY INTO PRACTICE

Now let's take a look at a number of examples showing how I use blend modes in my images to create effects, blend images, create composites, and so on.

Adding Fire

In this first example I want to add some fire to the foreground of a composite image I created. I photographed the model, Jessie, in the studio and added the background and floor later in Photoshop (**Figure 4.33**). As you'll see in the following steps, adding the fire is extremely easy to do with blend modes.

1. Open **jessie.jpg** in Photoshop, and then open the Libraries panel and type "flames" into the search field (**Figure 4.34**). This gives you a bunch of results from Adobe Stock.

FIGURE 4.33

FIGURE 4.34

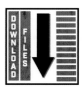

Download all the files you need to follow along step-by-step at: http://rockynook.com/pstoolbox

2. The handy thing here is that if you're not sure which image you want to use, you can try out various images before buying them by dragging one on top of your photograph and then using Free Transform to resize it (**Figure 4.35**). As you can see, if you haven't bought the stock image it has an Adobe Stock watermark, but once you license it that disappears.

3. With the flames in position all we need to do now is use a blend mode to add them to the image. Since the flames are on a black background, change the blend mode of the flames layer to one in the Lighten group (e.g. Lighten), which will remove black from the layer (**Figure 4.36**).

As always, it's a good idea to try a few other blend modes to see what results you get and what you prefer. In this case, I also tried the Screen blend mode (**Figure 4.37**), which made the flames look less contrasty and saturated, so I decided to stick with Lighten (**Figure 4.38**).

Having the ability to quickly remove the black from an image to blend it with another without having to make a selection is so incredibly handy. This is a technique I've used many times before and will continue to use in the future.

FIGURE 4.35

FIGURE 4.36

FIGURE 4.37 Using the Screen blend mode

FIGURE 4.38 Using the Lighten blend mode

In the picture of my friend Brian Dukes (**Figure 4.39** and **4.40**) and the picture of the stag (**Figure 4.41** and **4.42**), which is actually a composite I made, the snow came from files I'd made myself by filming 4K footage of fake snow falling in front of a black piece of cardstock (**Figure 4.43**).

To add the snow to each picture I simply positioned the file containing the snow at the top of the layer stack and changed the blend mode to Screen, which removed the black and left the snow. I added multiple layers of snow to create depth.

FIGURE 4.39 Before

NOTE *I've included the picture of Brian (brian.jpg) and a snow file (snow.jpg) from my Creativity Pack 2 in the downloads for this book so that you can give this technique a try.*

FIGURE 4.40 After

FIGURE 4.41 Before

FIGURE 4.42 After

FIGURE 4.43 Example of a snow file I created

Adding a Logo

In this example I want to add my logo onto one of my pictures before posting it online. However, when the logo was designed by my buddy Dave Clayton, it was originally blue on white (**Figure 4.44**).

I could keep the logo in blue, but I think it will look better if I change it to black or white before adding it to the picture, so let's go ahead and do that.

FIGURE 4.44
The original logo

FIGURE 4.45
The desaturated logo now looks grey

1. Open the **logo.jpg** file in Photoshop and go to *Image > Adjustments > Desaturate* to remove the color. The logo now looks gray (**Figure 4.45**). To turn it black, go to *Image > Adjustments > Levels* and choose the Set Black Point sampler in the Levels dialog (**Figure 4.46**), then zoom in and click anywhere on the logo itself (**Figure 4.47**). This tells Photoshop that where you clicked should be black, so Photoshop changes it to black (**Figure 4.48**)! Click OK to close the Levels dialog.

FIGURE 4.46

FIGURE 4.47 Select the Set Black Point sampler and click on the logo

FIGURE 4.48 The logo is now black

2. Open the **victorian.jpg** file by going to *File > Open*. Click on the tab containing the logo and select the Move Tool (V), then click on the logo and drag it onto the tab containing the victorian. jpg file. When you see the victorian.jpg file, drag the logo on top of it and release. The logo will now be above the Victorian female image in the layer stack (**Figure 4.49**).

3. Use the Move Tool (V) to drag the logo into the bottom-left corner of the picture. Go to *Edit > Free Transform*, hold down the Shift key, and drag the transform handles inward to reduce the size of the logo. Press Enter (PC) or Return (Mac) to commit the size transformation (**Figure 4.50**).

4. So that the logo is more visible on this dark picture, let's invert it by going to *Image > Adjustments > Invert*. We now have a white logo with a black surround. Now all we need to do is use one of the blend modes in the Lighten group to remove the black from the logo. Change the blend mode of the logo layer to Screen (**Figure 4.51**), and you're done (**Figure 4.52**). Easy, huh?!

FIGURE 4.49

FIGURE 4.50

FIGURE 4.51

FIGURE 4.52

Lining Up Layers with the Difference Blend Mode

Earlier in the chapter I mentioned that the Difference blend mode is great for lining up layers, so I thought I'd show you how that works and then take it a step further.

1. Open the **rosa.jpg** file in Photoshop and create a copy by pressing Ctrl + J (PC) or Command + J (Mac) (**Figure 4.53**).

2. Click on the rosa copy layer and change the blend mode to Difference (**Figure 4.54**), and you'll then see that the image turns completely black (**Figure 4.55**).

3. This happens because when you use the Difference blend mode, any parts of the BLEND layer and BASE layer that are identical will turn completely black (**Figure 4.55**). Any areas that aren't perfectly lined up would be obvious (**Figure 4.56**).

FIGURE 4.53

FIGURE 4.54

FIGURE 4.55 The image turns black when the Difference blend mode is applied, which means the layers are perfectly lined up.

FIGURE 4.56 I've moved the BLEND layer with the arrow keys on my keyboard, so the two layers are no longer perfectly aligned.

This is incredibly handy, for example, when you have two photographs taken in quick succession in which the person photographed maybe has their eyes closed, but is posed perfectly in one picture, and in the other picture their eyes are open, but they'd moved one of their hands. You can line the images up using the Difference blend mode and the arrow keys on the keyboard, and then consider using a layer mask to reveal or conceal different areas of each image to end up with an image in which the person is posed perfectly and has their eyes open.

Let's take it a step further. What if we wanted to line up two separate pictures, but it's not quite as simple as using the Difference blend mode because one of the pictures is at a slight angle?

Figures 4.57 and **4.58** show a couple of pictures that I took of photographer and friend Ian Munro. You'll find both files in the downloads folder for this book: ian_1.jpg and ian_2.jpg.

FIGURE 4.57

FIGURE 4.58

With ian_1 in the bottom layer position in Photoshop and ian_2 in the top layer position (**Figure 4.59**), if I change the blend mode of ian_2 to Difference, you can clearly see that it would take quite a bit of movement to get both layers lined up (**Figure 4.60**).

FIGURE 4.59

FIGURE 4.60 Setting the ian_2 layer to the Difference blend mode shows that the layers don't line up.

Ideally what I want to do is to mask out Ian's head in the ian_2 layer to reveal the head on ian_1. So here's a quick fix that will line up the layers in no time:

1. Open the **ian_1.jpg** and **ian_2.jpg** files in separate tabs in Photoshop, and then go to *File > Scripts > Load Files into Stack*.

2. In the Load Layers dialog box, click on *Add Open Files* (so that Photoshop knows it will be using the two pictures of Ian) and put a check mark in the *Attempt to Automatically Align Source Images* checkbox (**Figure 4.61**). Click OK.

3. Photoshop has now adjusted the position and orientation of the layers so that any identical areas, such as the chair and Ian's legs, are lined up. Change the blend mode of the uppermost layer (ian_2) to Difference to see that those areas turn black, meaning they are aligned (**Figure 4.62**). Once you've checked this, change the blend mode back to Normal.

FIGURE 4.61

FIGURE 4.62

FIGURE 4.63

4. We only want to see the head from ian_1, so to make the masking easier drag the ian_2 layer to the top of the layer stack, and then click to add a layer mask (**Figure 4.63**).

5. Click on the layer mask in the Layers panel so that it is active (the frame is visible around it). Using a normal round, soft-edged brush and a black foreground color, paint directly on the picture of Ian to mask away the head from the upper layer and reveal the head from the layer beneath (**Figure 4.64**).

Now that the layers have been aligned and we've masked out the head, we could carry on with other retouching steps, but this technique again shows that there is always more than one way to do the same thing in Photoshop, and some ways are simply more time efficient.

FIGURE 4.64

FIGURE 4.65

Using Difference for Color Correction

This next technique is one I absolutely love! It is a superb way to color correct pictures, and is a really clever, but logical use of the Difference blend mode, as you'll see.

We're going to use a method whereby we need to tell Photoshop what is black and what is white in the picture, which is very simple to do; however, the clever part is identifying the 50% gray areas so we can do a much more accurate color correction.

1. Open the **harley.jpg** image in Photoshop. Can you see how there's a slight green color cast across the picture (**Figure 4.65**)? To fix this, start by adding a Threshold adjustment layer (**Figure 4.66**), and in the Properties panel drag the marker all the way to the left side (**Figure 4.67**). Doing so will likely make the picture turn completely white. When you then begin to slowly drag the marker back across to the right, you will start to see areas of the picture reappear (showing up in black). The first areas that start to reappear will be the black areas within the picture (**Figure 4.68**).

FIGURE 4.66

FIGURE 4.67 FIGURE 4.68

2. To tell Photoshop which area of the picture is black, grab the Color Sampler Tool from the toolbar (**Figure 4.69**) and click on the image in a black area. I clicked just underneath motorcycle's fuel tank (**Figure 4.70**). You'll notice that doing this leaves a numbered marker where you clicked.

FIGURE 4.69 FIGURE 4.70

3. Now go back to the Threshold Properties and drag the Threshold marker all the way over to the right side so that the picture turns black, and then slowly drag the marker back across to the left. As you do this, areas of the image start to show up in white, and indicating what is actually white within the picture (**Figure 4.71**). With the Color Sampler Tool, click down on a white area. I chose to click on the motorcycle's forks (**Figure 4.72**). This will leave another marker in the image, which in this case has the number 2 next to it.

FIGURE 4.71 FIGURE 4.72

4. At this point you can delete the Threshold adjustment layer because we only needed it to identify the black and white points in the picture, which we marked using the Color Sampler Tool. Click on the Threshold adjustment layer and press delete, or simply drag the adjustment layer on top of the trash can icon at the bottom of the Layers panel.

5. Click to add a Levels adjustment layer (**Figure 4.73**). In the Properties panel choose the Set Black Point sampler (**Figure 4.74**), and then click directly in the middle of the number 1 marker, which indicates the black area within the picture. When you do this you may see a slight change in the picture.

6. Now choose the Set White Point sampler (**Figure 4.75**) and click directly in the center of the number 2 marker, which indicates a white area within the picture. Again, you may see a slight change in the image.

FIGURE 4.73

FIGURE 4.74

FIGURE 4.75

Now we need to use the Set Gray Point sampler, and here's how we can establish the gray areas within the picture:

7. Add a new blank layer above the Background layer in the layer stack. Go to *Edit > Fill*, choose 50% Gray from the Contents drop-down menu, and click OK. In the Layers panel, change the blend mode of this 50% gray layer to Difference (**Figure 4.76**).

8. Remember that when we use the Difference blend mode, any areas where the layers are identical show up as black. Well, here we have applied the Difference blend mode

FIGURE 4.76

to a 50% gray layer, so now any areas that show up as black are 50% gray in the picture, and that's exactly what we need to know.

9. Select the Color Sampler Tool and click down on a black area, and you'll notice that another numbered marker is left where you clicked—this time number 3. I clicked on the biker's (Sam's) shoulder (**Figure 4.77**). Now you can delete the 50% gray layer.

10. Click on the Levels adjustment layer in the layer stack to open the Properties, and then choose the Set Gray Point sampler (**Figure 4.78**). Click directly in the middle of the number 3 marker on the picture.

FIGURE 4.77

FIGURE 4.78

11. We have now color corrected the image to remove the green color cast, and you can adjust the Opacity of the Levels layer to suit your taste. In my example, I lowered the Opacity of the Levels adjustment to 60%.

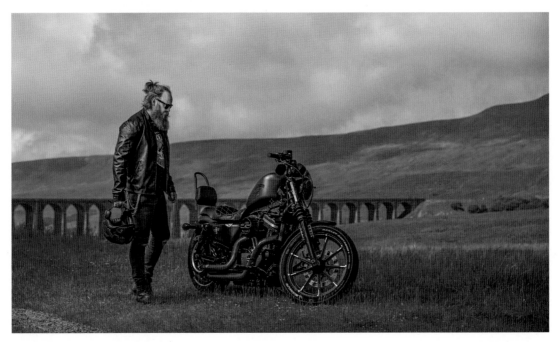

FIGURE 4.79 Before color correction

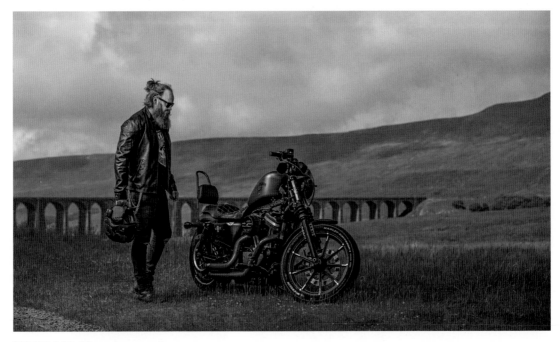

FIGURE 4.80 After color correction

NOTE *To remove the markers that were put in place with the Color Sampler Tool, make sure the Color Sampler Tool is selected and click on Clear All in the options bar at the top of the screen (Figure 4.81).*

FIGURE 4.81

Textures

To put it in the simplest terms, I absolutely love textures! I've used and continue to use them in so many of my pictures, whether it's to add in new backgrounds or floors or simply to give the image an artistic or aged feel. There's so much you can do with textures.

Each of the pictures shown in **Figures 4.82–4.85** started off with a plain gray paper background behind the subject, and the texture was applied in Photoshop.

FIGURE 4.82

FIGURE 4.83

FIGURE 4.84

FIGURE 4.85

I want to take a moment to show you how I use textures in my portraits. When I say a moment, I really do mean a moment because you'll see how quickly and easily you can transform your pictures by adding textures.

As an example, I'll show you how easy it is to add in a new background or floor by using a blend mode, without the need for making complex selections and cutouts.

1. Open the **ragged_victorians.jpg** picture in Photoshop. You can see here that the subjects were photographed against a seamless roll of gray paper (**Figure 4.86**).

2. Go to *File > Place Embedded* or *File > Place* (depending on which version of Photoshop you are currently using), navigate to **texture_1. jpg**, and click Place. This will add the texture to the top of the layer stack (**Figure 4.87**). Drag the transform handles outward until the texture completely covers the portrait of the Ragged Victorians (**Figure 4.88**). If you don't see any transform handles, go to *Edit > Free Transform*. Press Enter (PC) or Return (Mac) to confirm the placement of the texture.

FIGURE 4.86

FIGURE 4.87

FIGURE 4.88

In the overview of the blend modes I mentioned that with Soft Light if the colors on the BLEND (in this case, the texture) are darker than the BASE (Ragged Victorians), then they are darkened. If the colors on the BLEND are lighter than the BASE, then they are lightened. Areas that are 50% gray remain unaffected, and the result of the blend adds a subtle amount of contrast.

With that in mind, let's see what happens when we use the Soft Light blend mode for this image.

3. Change the blend mode of the texture_1 layer to Soft Light (**Figure 4.89**). Look how the texture seems to blend into the seamless gray paper (**Figure 4.90**)—cool, huh?! There are traces of the texture on the Ragged Victorians, but we can sort that out in a moment.

FIGURE 4.89

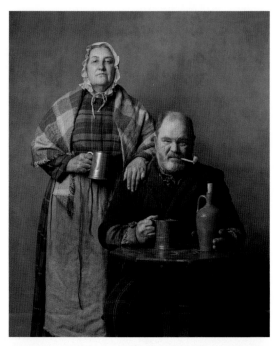

FIGURE 4.90

4. For now, let's add one more texture. Use the *File > Place Embedded* or *File > Place* again to add **texture_2.jpg** to the top of the layer stack (**Figure 4.91**). This time change the blend mode to Overlay. Notice that now there is much more contrast and this is because of how Overlay behaves (**Figure 4.92**).

5. Now that we've added a couple of texture layers, we need to remove the texture from the subjects in the picture. Click on texture_1 in the layer stack, hold down the Shift key, and click on texture_2 so that both texture layers are highlighted. Then go to *Layer > New > Group from Layers*, name the group **texture**, and click OK (**Figure 4.93**).

FIGURE 4.91

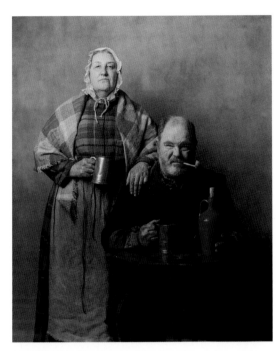

FIGURE 4.92 The Overlay blend mode creates much more contrast

FIGURE 4.93

NOTE *After grouping the textures I lowered the Opacity of the group to around 60% to reduce the overall effect of the textures on the background—done for no other reason than my own personal taste.*

6. Click on the Add Layer Mask icon at the bottom of the Layers panel to add a layer mask to the texture group. With a normal round, soft-edged brush and black foreground color, paint over the picture to hide (conceal) the texture in areas you don't want it to be visible (i.e., the ragged Victorians, the table, the tankard, etc.) (**Figure 4.94**).

 NOTE *When you place layers into a group, you'll see that the blend mode of the group is Pass Through. This is basically telling Photoshop to look into the group and continue to apply the blend modes of the layers within it. You could always experiment here and change the blend mode of the group to see what results you get.*

That's all there is to it! Now you're ready to carry on with any other retouching you'd like to do.

FIGURE 4.94

FIGURE 4.95 No texture

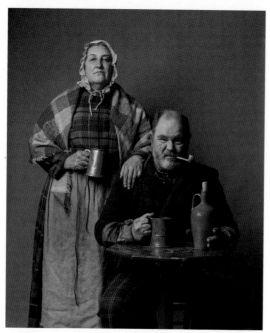

FIGURE 4.96 Texture added

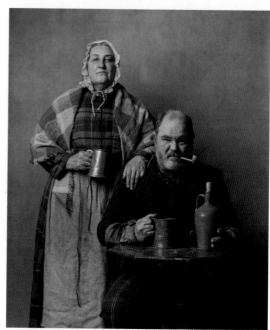

FIGURE 4.97 Final edit

Removing Skin Shine

So far we've looked at blend modes that we can access within the Layers panel, but blend modes do actually appear in other places within Photoshop, such as with Brushes, the Healing Brush, Clone Stamp Tool, Gradient Tool, and so on.

Here I want to show you my preferred technique for removing or reducing skin shine, whereby I use a blend mode with the Healing Brush for a very realistic result.

1. With the **foxy.jpg** file open in Photoshop, click on the Add New Layer icon at the bottom of the Layers panel to add a new blank layer (**Figure 4.98**). Double-click on the layer name and rename it **skin shine**, then press Enter (PC) or Return (Mac).

> **NOTE** *By using a blank layer we're working nondestructively, so we can remove the shine but still keep our original image safe and untouched.*

2. Choose the Healing Brush from the toolbar (**Figure 4.99**) and in the options bar at the top of the screen, change the Mode of the Healing Brush from Normal to Darken. Also ensure that Sample is set to All Layers (**Figure 4.100**).

FIGURE 4.98

FIGURE 4.99

FIGURE 4.100

3. We're going to remove/reduce the skin shine on Foxy's forehead and the little bit on his nose. First, position the Healing Brush over an area of Foxy's forehead that isn't shiny, but is near the shiny area we're going to work on, and then while holding down the Alt (PC) or Option (Mac) key, click down once to sample the skin (**Figure 4.101**). This tells Photoshop what area of skin to use when covering over the shiny area.

4. Now that you've sampled the area of skin, you can start to brush over the shiny area so that Photoshop can start to remove or reduce it. For best results, the trick is to continually take samples of non-shiny skin as you're brushing over the shiny area, rather than only using the first sample that you took.

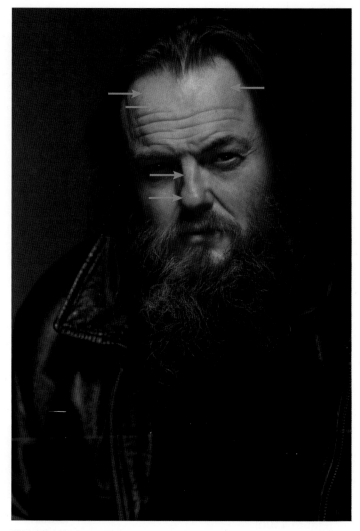

FIGURE 4.101 I sampled areas of skin that aren't shiny, but are near the shiny areas

On the opposite side of that, if you were working on a picture with an area that was darker than the area around it, you could try setting the Healing Brush to the Lighten blend mode. In theory, this would only lighten areas that were darker than the area you sampled.

WHY USE THE DARKEN BLEND MODE? *When we sample the non-shiny skin with the Healing Brush set to the Darken blend mode, Photoshop will only darken areas of skin that are lighter/brighter than the area we sampled. So in this case, since the shiny skin is lighter/brighter than the area of non-shiny skin, Photoshop will only "heal" those shiny areas and will leave other areas completely untouched. This way it won't heal areas of skin that it doesn't need to, which can look obvious and often produces a smudged-looking result.*

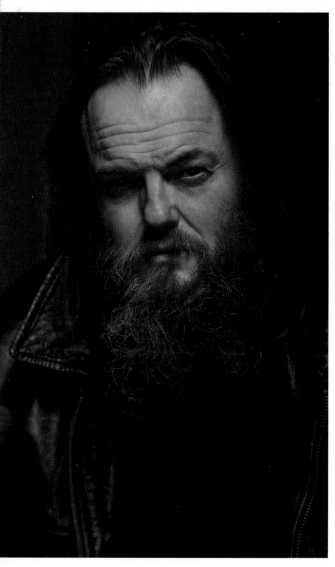

FIGURE 4.102 Before

FIGURE 4.103 Final edit of actor Simon "Foxy" Fowler with skin shine removed and finishing touches

NOTE *I've recorded a video on my YouTube channel where I take this technique a step further and show how to retain the skin texture. You can check it out at the following URL: bit.ly/tptb_skin*

Dodging and Burning

Like with most techniques in Photoshop, there's more than one way to dodge and burn, but however you choose to do it, you have to be careful because it's definitely one of those things you can get carried away with and before you know it, you've done way too much. That's exactly why I choose to use the technique I'm going to show you in this section (**Figure 4.104**).

While we're on the subject of dodging and burning, a few years back a retoucher friend of mine recommended a DVD set of training material that goes through dodging and burning pixel by pixel—seriously heavy stuff. After about 10 minutes of watching I couldn't watch anymore because the instructor's voice was so incredibly monotone that all I could think about was the scene in *Ferris Bueller's Day Off* when the teacher keeps calling out "Bueller....Bueller." I told my friend I couldn't watch it, but she convinced me to stick with it, saying the instructor does get into his groove and it improves. But, let me tell you, after four hours he didn't!

Now I'll never get that time back and I don't want you to go through the same, so this technique is a lot simpler. It is nondestructive and produces great results, so let's get started.

FIGURE 4.104

FIGURE 4.105

1. With the **lissy.jpg** file open in Photoshop, add a new blank layer to the top of the layer stack by going *Layer > New > Layer*. In the New Layer dialog, name the layer **Dodge + Burn**, change the Mode to Soft Light, put a check mark in the checkbox labeled Fill with Soft-Light-neutral color (50% gray), and click OK (**Figure 4.105**).

 What we have now is a 50% gray layer at the top of the layer stack, but we can still see the lissy.jpg image. Why is that?

 First of all, the reason we've added a new layer as opposed to either working directly on our picture or working on a copy of our picture is so that we can work nondestructively. The reason we've added 50% gray into this new layer is because we need pixels to dodge and burn (make brighter and darker), and a blank layer doesn't contain any pixels. Because 50% gray is a neutral color, when we do the dodging and burning, we won't see any color artifacts appear. We also use gray because with blend modes we can make it transparent and keep the pixels on the layer.

2. Select the Dodge Tool from the toolbar (**Figure 4.106**). In the options bar at the top of the screen, leave the Range set to Midtones (there's no point in changing this since we'll be working on a 50% gray layer), lower the Exposure (strength) to around 5%, and turn on the icon (or put a check mark in the checkbox) for Protect Tones (**Figure 4.107**).

NOTE *It's best to keep the Exposure setting fairly low so that you build up the effect gently. When dodging and burning, it's easy to do too much without realizing it.*

FIGURE 4.106 FIGURE 4.107

3. Now you're all set to start dodging and burning. There's so much that can be said about how to do it, but let's keep it simple and say that the main objective here is to add depth and dimension by brightening the bright parts and darkening the dark parts. You can toggle quickly between the Dodge Tool and the Burn Tool by simply holding down the Alt (PC) or Option (Mac) key. You won't see any changes in the toolbar, but you will be using the opposite tool, and the great thing here is that it will maintain the same settings in the options bar as you switch between the tools. For example, if you're using the Dodge Tool at 5% Exposure and then hold down the Alt (PC) or Option (Mac) key, you will then be using the Burn Tool with 5% Exposure. **Figure 4.108** shows where I have worked on the picture of Lissy.

FIGURE 4.108

 TIP *To see only the gray layer you're working on, hold down the Alt (PC) or Option (Mac) key and click on the eye icon next to the gray (Dodge + Burn) layer in the Layers panel. This will turn off every other layer. To go back to the normal view, hold down the Alt (PC) or Option (Mac) key and click on the eye icon for the gray (Dodge + Burn) layer again.*

4. You could also choose to dodge and burn on the gray layer by using a combination of black and white brushes, and this would work fine. However, the reason I choose not to is so that I can set my foreground color to 50% gray by clicking on the foreground color in the toolbar and setting the HSB (Hue, Saturation, Brightness) values to 0, 0, 50 (**Figure 4.109**). Then when I'm dodging and burning, if I need to remove or reduce the effect anywhere I can quickly select a brush and paint over the area with a 50% gray color at whatever opacity I choose (**Figure 4.110** and **4.111**).

FIGURE 4.109

FIGURE 4.110

FIGURE 4.111

In **Figure 4.111** you can see that the dodge and burn has been reduced by 50% on Lissy's hair and nose, and has been completely removed from her mouth. You can also see how the area under her eyes was dodged (lightened) to reduce the dark areas.

FIGURE 4.112 Before

FIGURE 4.113 After

The Never-Ending Lighting Rig

I wanted to make sure to include this technique because it's one that I have used more times than I care to remember. I call it the Never-Ending Lighting Rig because with this incredibly simple technique you can actually make it look as though you had more lights with you at the time of your photo shoot to light other areas in the picture. Of course, I'm not suggesting you use this technique instead of capturing it all in-camera, but there are times when, for one reason or another (usually time constraints), that's not possible, and Photoshop can give us a helping hand.

As an example, we're going to use a picture I took of my dear friend Tom and his gorgeous dog Ruby in one of the barns on his farm (**Figure 4.114**).

FIGURE 4.114 Tom and Ruby

1. With the **tom.jpg** file open in Photoshop, add a new blank layer to the top of the layer stack and name it **Light**.

2. With the foreground color in the toolbar set to white, choose a normal round, soft-edged brush with 100% Opacity and 100% Flow at around 400px. Click to place a single dot in the center of the picture (**Figure 4.115**).

> **NOTE** *We want to use a normal round, soft-edged brush for this effect, so make sure when you use the brush that there are no settings active in the Brush Settings panel.*

FIGURE 4.115

3. With the Move Tool selected, click on the dot and move it around the picture. Obviously, it doesn't look like a real light source at the moment, but if you change the blend mode of the Light layer to Overlay (**Figure 4.116**) and then move the dot around, check out the difference—you now have a light source.

4. To resize this light source, go to *Edit > Free Transform* and while holding down Shift + Alt (PC) or Shift + Option (Mac), click and drag any of the corner transform handles outward or inward (**Figure 4.117**).

FIGURE 4.116

FIGURE 4.117

5. Despite the brush having been at the maximum 100% Opacity, we can also make the light source brighter by duplicating the Light layer. Make sure the Light layer is selected and press Ctrl + J (PC) or Command + J (Mac) to create a duplicate, or simply drag the Light layer on top of the Add New Layer icon at the bottom of the Layers panel.

6. Put both layers (Light and Light copy) into a group by first clicking on the top layer, and then holding down the Shift key and clicking on the layer beneath so that both layers are highlighted (**Figure 4.118**). Then go to *Layer > New > Group from Layers*.

7. Name this group **Light 1**, and then close the group by clicking the arrow next to the folder icon in the Layers panel. With the Move Tool (V), drag the light source around the picture to reposition it.

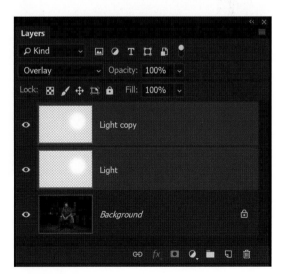

FIGURE 4.118

8. Now that the Light and Light copy layers are in a group, you can use Free Transform to resize the light source, and you can change the Opacity of the group in the Layers panel to adjust the brightness if the effect is too bright (**Figures 4.119** and **4.120**).

 TIP *If you want to add more light sources, rather than repeating these steps, simply duplicate the group by pressing Shift + Alt (PC) or Shift + Option (Mac) or dragging the group onto the Create New Group icon at the bottom of the Layers panel.*

FIGURE 4.119

FIGURE 4.120

The reason I love this technique is because of the Overlay blend mode. With Overlay, if the colors on the BLEND are lighter than the BASE, then they are screened. In this case, the Light layer is the BLEND, and with it being a white dot, the areas beneath it are screened (brightened), resulting in this fake light source. Handy, right?

In Adobe Camera Raw and Lightroom, you can use the Radial Filter to draw out an ellipse and adjust the exposure, shadows, etc., for a particular area in the picture; however, all that does is brighten that part of the picture. When you use a blend mode (in this case, Overlay), the light source reacts with the contrast and tone in the picture so the result is much more realistic. Like I've said before, it's the small things that make the big difference when using Photoshop!

More Overlay Magic - Perfect Layer Masks

Before we jump into the Bonus Content chapter, I wanted to go through a superb technique using the Overlay blend mode. If you ever do cutouts and selections and use layer masks like I covered in chapter 2, you'll absolutely love this!

Let's say that we're working on putting a composite together and we need to cut the tree in **Figure 4.121** out from its original background so that we can use it in another picture.

FIGURE 4.121

1. With the **tree.jpg** file open in Photoshop, go to *Select > Color Range*. In the Color Range dialog drag the Fuzziness slider to the left to around 25 (for now).

If you don't know how Color Range works, it's basically a way to make selections based on color. If you choose the Eye Dropper Tool from the Color Range dialog and then click down directly onto the tree image, you will see some areas in the preview turn white. These are areas that are the same as the color directly underneath where you clicked, and these are the areas you are selecting.

For example, if I click on an area of green leaves, you can see areas that are the same shade of green represented in the preview in **Figure 4.122**. If I click on the sky, you can see it in the preview in **Figure 4.123**.

FIGURE 4.122

FIGURE 4.123

The Fuzziness slider is Photoshop's way of being super friendly and saying, "Hey, I know you want the color you just clicked on, but if you move this Fuzziness slider to the right, I'll add more colors in. If you drag it to the left, I'll remove colors so that you're selecting less area." Get it?

Okay, let's use this function to select the tree.

2. Select the Eye Dropper Tool and click on an area of the leaves. Then grab the Add to Sample Tool and add to this selection by clicking and dragging over other areas of the leaves and branches. It's highly likely you'll select other areas, but don't worry too much about that. Now drag the Fuzziness slider over to the right a bit. I moved it to around 69, as this seems to select more of the tree (**Figure 4.124**).

FIGURE 4.124

3. Click OK to exit the Color Range dialog. Upon doing so, you'll see lots of marching ants selections all over the picture (**Figure 4.125**). I don't know about you, but I think it can be quite difficult to see what is and isn't selected, so this is where I use Quick Mask, which we looked at in chapter 2.

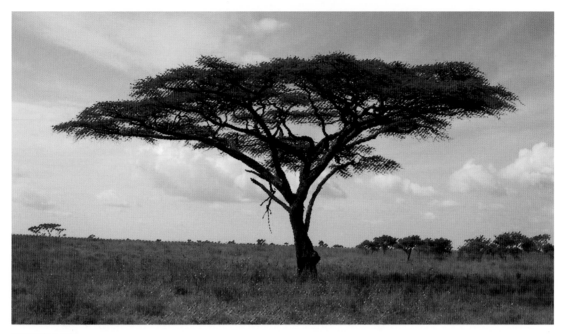

FIGURE 4.125

4. Press Q on the keyboard or press the Quick Mask icon in the toolbar to enter Quick Mask Mode. When you do this you can clearly see what is and isn't included in the selection—areas that aren't included are covered with the red overlay (**Figure 4.126**). We only want the tree to be selected, but at the moment the ground is selected, too, so choose a normal round, soft-edged brush with a black foreground color and paint over the ground (white reveals, black conceals) (**Figure 4.127**).

5. Press Q to exit Quick Mask Mode and go back to seeing the marching ant selection, and then to cut the tree from its background, click on the Add Layer Mask icon at the bottom of the Layers panel (**Figure 4.128**).

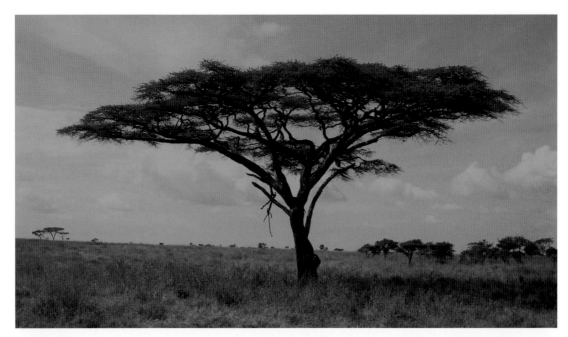

FIGURE 4.126

FIGURE 4.127

FIGURE 4.128

Now comes the magic of the Overlay blend mode...

6. Hold down the Alt (PC) or Option (Mac) key and click directly on the layer mask attached to the tree layer to get the layer mask view. Now you can see how good your selection and cutout really is (**Figure 4.129**).

FIGURE 4.129

7. In **Figure 4.130**, you can see that there are some gray areas on the layer mask in the area of the sky, meaning those areas will be partly visible. Only areas that are solid black will be hidden from view. If you use a black brush to paint over these areas it can be very difficult to avoid painting over the tree; however, if you change the blend mode of the brush to Overlay in the options bar at the top of the screen (**Figure 4.131**), you can paint in black without affecting the white areas of the tree.

FIGURE 4.130

FIGURE 4.131

Also, if there are areas that are gray but should be solid white, you can paint with a white brush set to the Overlay blend mode without affecting the black areas (**Figure 4.132**).

Using the Overlay blend mode makes it so that the brush will only affect gray areas, regardless of whether you're painting on the layer mask in white or black. If you paint in white, the black is left alone, and if you paint in black, the white is left alone; only grey is affected.

8. Now that we've tidied up the layer mask, hold down the Alt (PC) or Option (Mac) key and click on the layer mask attached to the tree layer to go back to the normal view so you can see the tree cutout (**Figure 4.133**).

FIGURE 4.132

FIGURE 4.133

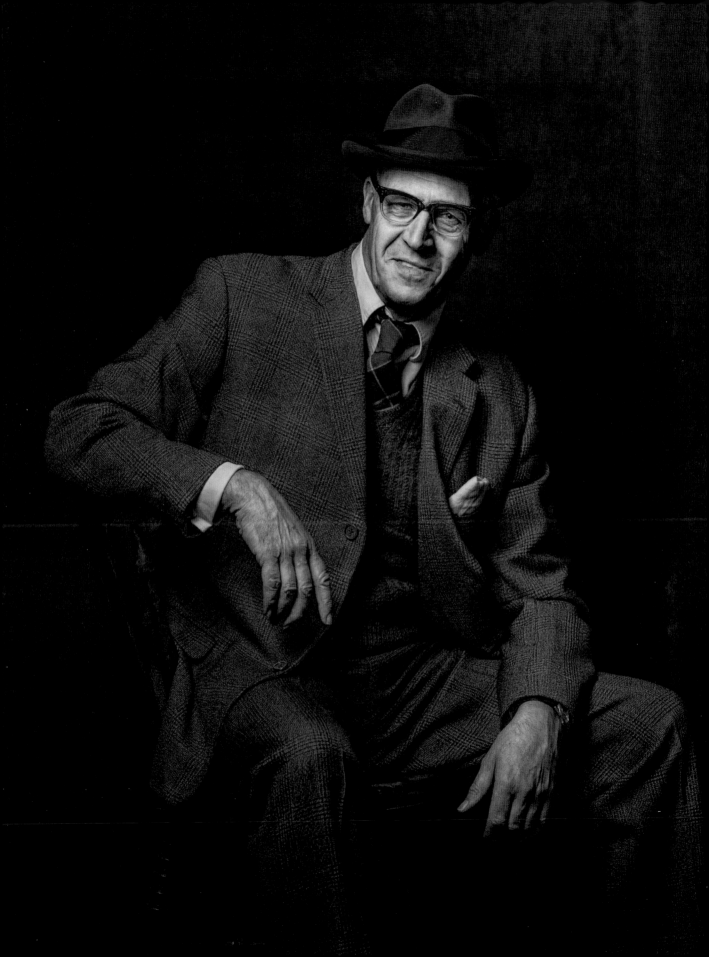

I couldn't think of a better name for this chapter other than Bonus. I guess that fits, though, because this is where I want to share a bunch of techniques that I either use on a regular basis or that have helped me out BIG TIME in the past. Truth be told, because these techniques are so varied they didn't really fit elsewhere in the book, so I thought I'd add in this chapter as an excuse to give you more.

Let's face it—everyone loves a bonus, right?!

FIGURE 5.1

CONTENT-AWARE FILL TRICK

Imagine a scenario where you take a group photograph, and then a short time later, the company that hired you asks if you can remove someone from the final photograph. For example, in **Figure 5.1**, let's say we need to remove the guy in the back row, second from the left.

My first thought would be to use Content-Aware Fill to see how well that works. We'd need to start by making a selection of the man to be removed, which we could do using the Quick Selection Tool (W) (**Figure 5.2**).

1. Open the **group.psd** file in Photoshop. I've already created a selection for you, so just go to *Select > Load Selection*, select male from the Channel menu, and click OK.

2. With the marching ants selection visible, go to *Edit > Fill*, choose Content-Aware from the Contents menu, and click OK (**Figure 5.3**).

That doesn't seem to work too well, does it? Although, the guy sitting down in the front might think otherwise now that he's developed a full head of hair (**Figure 5.4**).

Download all the files you need to follow along step-by-step at: http://rockynook.com/pstoolbox

FIGURE 5.2

FIGURE 5.3

So why didn't that work? Basically, when we had a selection around the man that we wanted to remove and then tried to use Content-Aware to fill it, Photoshop looked outside of the selection and thought it was okay to use any other parts of the photograph to cover the man.

FIGURE 5.4

This technique might work if the person or object we want to remove is on its own, but in this case, the man is mixed in closely with other people. We somehow need to be able to tell Photoshop what it can and can't use to fill the selection, and here's the trick to doing exactly that:

1. Let's start over with the original group picture. This time, before loading the selection, press Ctrl + J (PC) or Command + J (Mac) to duplicate the picture. Then go to go to *Select > Load Selection*, choose male from the Channel menu, and click OK. With the marching ants selection visible around the man, grab the Lasso Tool (L), hold down the Shift key (to add to the selection), and drag out a line around the areas you want Photoshop to use when we try Content-Aware again (**Figure 5.5**).

FIGURE 5.5

NOTE *If you were doing this from scratch and didn't have a selection already made (like the one I have saved for you), you would need to make a selection of the man (or object) you want to remove on the duplicate layer, and save it by going to* Select > Save Selection, *giving it a relevant name, and clicking OK.*

2. With this new marching ants selection visible, click to add a layer mask, and then make sure you click on the thumbnail of the group picture in Layer 1 so that the layer mask doesn't have the frame around it (**Figure 5.6**).

FIGURE 5.6

Now here's the clever bit…

In theory, now that we've added a layer mask, Photoshop can only see the areas of that layer that are white on the layer mask (remember, white reveals, black conceals). This means that when Photoshop tries to use parts of the photograph to hide the man, it can only use those visible areas of the photograph. Are you with me? Let's try it.

3. Go to *Select > Load Selection*, choose male from the Channel menu, and click OK. This loads the original selection around the man we want to remove (**Figure 5.7**). Now go to *Edit > Fill*, choose Content-Aware from the Contents menu, and click OK. Go to *Select > Deselect* to remove the marching ants. This is a much better result, right (**Figure 5.8**)?

FIGURE 5.7

4. All we need to do now is tidy up and remove some of the remaining parts or areas that didn't blend so well. Use the Lasso Tool to select them (**Figure 5.9**), and then use Content-Aware Fill again to remove them. This can be done very quickly.

FIGURE 5.8

FIGURE 5.9

FIGURE 5.10 Before

FIGURE 5.11 After

HOW TO MATCH COLOR

One thing I didn't mention about the picture in the previous section was that when I was first hired, the company assured me that the seating the staff would be using was all the same color; however, as you can see in the "out of camera" image, that wasn't the case (**Figure 5.12**).

FIGURE 5.12

So, I needed to change the color of the sofa to match that of the armchair. Let me show you the technique I used.

1. With the **wrongcolor.psd** file open in Photoshop, we'll start off by making a selection of the yellow sofa. You can do this using whatever method you prefer (I used a combination of the Quick Selection Tool and Quick Mask), but I've created a selection for you to make life a little easier. Go to *Select > Load Selection*, choose sofa from the Channel menu, and click OK. You will now see an active selection around the sofa (**Figure 5.13**).

FIGURE 5.13

2. This selection needs to be placed on its own layer, so press Ctrl + J (PC) or Command + J (Mac) or go to *Layer > New > Layer via Copy* to add the selection (cutout) of the sofa onto the layer above the Background layer in the Layers panel. Double-click on the Layer 1 name and rename it **sofa (Figure 5.14)**.

At this point, you could try to use a variety of color adjustments to make the sofa match the color of the armchair, but that would be very challenging, to say the least. Here's how to make the process a lot easier:

FIGURE 5.14

3. Click on the sofa layer in the Layers panel so that it is highlighted—this is the layer we are working on. Zoom in on the image, and then grab the Rectangular Marquee Tool and drag out a small selection on the arm of the sofa (**Figure 5.15**). Hold down Ctrl + Alt (PC) or Command + Option (Mac) as you click on the selected area and drag it over onto the brown armchair (**Figure 5.16**). Go to *Select > Deselect* to remove the active selection around the swatch.

FIGURE 5.15

FIGURE 5.16

The reason we have made this swatch and kept it on the same layer as the sofa is so we can match the color of the swatch to the color of the armchair. We want it to blend in and almost disappear completely. When we do this, the adjustments we make to the swatch will also be made to the sofa.

Now we're going to use grayscale values to change the color of the swatch. That may sound difficult, but believe me, it isn't.

This image is in the Adobe RGB color space, and when we click on the Channels tab we can see how the image is made up (**Figure 5.17**). At the top of the Channels panel is the RGB full-color version of our picture. Underneath that we see the Red, Green, and Blue channels. The RGB channel at the top is a combination of these three.

The Red, Green, and Blue channels are represented as grayscale values. If you click on a channel thumbnail, it is reflected in the image in the main workspace, and you can see how the three channels vary (**Figures 5.18–5.20**). So how is this going to help? I'll show you.

FIGURE 5.17

FIGURE 5.18 Red

FIGURE 5.19 Green

FIGURE 5.20 Blue

4. Click on the Red channel thumbnail and then zoom in to concentrate on the armchair and swatch area. Basically, the idea is to match the Red channel values of the swatch with the Red channel values of the armchair so that the swatch pretty much disappears.

Go to *Image > Adjustments > Curves* and you'll see that the Red channel is already selected in the Curves dialog (**Figure 5.21**). Click on the Target Adjustment Tool in the bottom-left corner of the dialog (looks like a hand with a pointed index finger and arrows above and below). Position the dropper just above the swatch in the image, click down, and slowly start dragging downward (**Figure 5.22**).

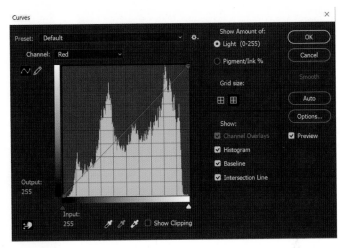

FIGURE 5.21

As you drag slowly downward you'll see that the swatch starts to darken. You may need to take short pauses as you drag to see the swatch change, but don't release the cursor when you pause. Drag down until the swatch pretty much disappears, and then release (**Figure 5.23**). (You might find it useful to either squint or look away and look back as you do this; otherwise, you can become fixated on the swatch and you'll see it no matter what you do). Click OK when you're happy with the results.

FIGURE 5.22

FIGURE 5.23 Dragging down with the Target Adjust-ment Tool adjusts the Red channel

This process needs to be repeated on the Green and Blue channels.

5. Click on the Green channel thumbnail and go to *Image > Adjustments > Curves*. Grab the Target Adjustment Tool, position the cursor just above the swatch, and click and drag downward until the swatch blends in and is as close to disappearing as you can get it (**Figure 5.24**)

6. Click on the Blue channel thumbnail and go to *Image > Adjustments > Curves*. Grab the Target Adjustment Tool, position the cursor just above the swatch, and click and drag downward until the swatch blends in (**Figure 5.25**).

FIGURE 5.24 Adjusting the Green channel

FIGURE 5.25 Adjusting the Blue channel

7. Now that we have matched the red, green, and blue values of the swatch to the red, green, and blue values of the sofa, click on the RGB channel to go back to the normal full-color view (**Figure 5.26**). Zoom back out to see how the adjustments have affected the yellow sofa (**Figure 5.27**).

At this point we no longer need the swatch, so just use the Eraser Tool to remove it from the armchair.

FIGURE 5.26

By using this technique we've managed to change the original color of the sofa to something extremely close to that of the armchair. The other challenge I faced with this image was the difference in material; unlike the sofa, the armchair was leather. I have a video on my YouTube channel showing this whole process, and at the end I show how to use the Plastic Wrap Filter to mimic the look of the armchair and finish up with a fantastic result: bit.ly/tptb_sofa.

FIGURE 5.27

FAKE CATCH LIGHTS

Do you remember the Never-Ending Lighting Rig technique I went through in chapter 4? Well, we can use the same principles to create fake catch lights, which again is an example of how one technique can be used in many ways.

1. Open the **lewis_seat.jpg** file in Photoshop, zoom in on the face (**Figure 5.28**), and add a new blank layer to the top of the layer stack. Name this layer **eye-left** (**Figure 5.29**).

FIGURE 5.28

FIGURE 5.29

2. Grab the Elliptical Marquee Tool from the toolbar (**Figure 5.30**) and while holding down the Shift key, click and drag out an ellipse around the eye on the left side of the image (**Figure 5.31**).

> ⭐ **TIP** *To move the selection around as you click and drag, hold down the space bar.*

3. Once you have drawn an ellipse, hold down the Alt (PC) or Option (Mac) key and draw out another ellipse on the top of the previous ellipse, but leave out an area in the lower portion. This removes the top area of the selection (**Figure 5.32**).

FIGURE 5.30

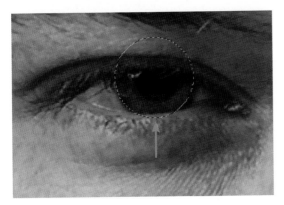

FIGURE 5.31

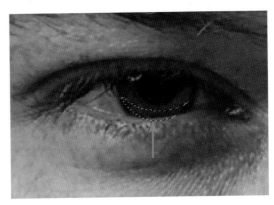

FIGURE 5.32

4. Go to *Edit > Fill*, choose White from the Contents menu, and click OK. This fills the selection with white. Remove the selection by going to *Select > Deselect* (**Figure 5.33**).

5. Now we need to blur this white catch light by going to *Filter > Blur > Gaussian Blur*. Dial in a Radius of around 2 Pixels and click OK (**Figure 5.34**).

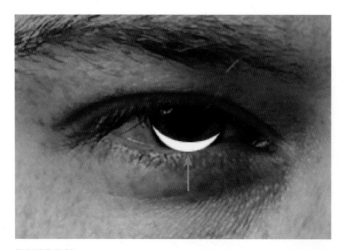

FIGURE 5.33

FIGURE 5.34

6. To blend the catch light into the eye, change the blend mode of the eye-left layer to Overlay, just like we did with the Never-Ending Lighting Rig in chapter 4. Use Opacity to dial in the strength of the effect according to your preference. In this case, I used an Opacity of 70% (**Figure 5.35**).

7. Create a duplicate of the eye-left layer by pressing Ctrl + J (PC) or Command + J (Mac) and rename this layer **eye-right** (**Figure 5.36**). Use the Move Tool (V) to drag the catch light across the image and position it over the right eye.

FIGURE 5.35

8. With the eye-right layer highlighted in the Layers panel, hold down the Shift key and click on the layer beneath (eye-left) so that both layers are highlighted. Then go to *Layer > New > Group from Layers*, name the group **eyes**, and click OK. Add a layer mask to this group by clicking on the Add Layer Mask icon at the bottom of the Layers panel (**Figure 5.37**).

9. With a normal round, soft-edged brush and a black foreground color, paint over any areas of the catch lights that you don't want to appear in the final image. That's it!

FIGURE 5.36

FIGURE 5.37

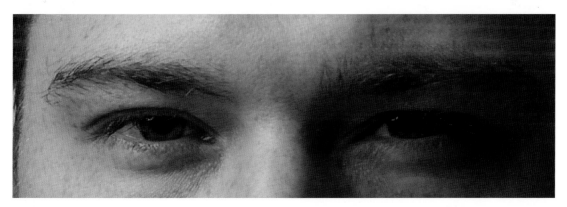

FIGURE 5.38 Before

FIGURE 5.39 After

REPLACING SKY SUPER FAST

In chapter 2 I shared a technique for replacing the sky. In this section I want to show you another technique that you can add to your Photoshop toolbox for doing the same thing super fast! Of course, with Photoshop being Photoshop, this might not work on every picture, but as we know, it's great to have a number of techniques you can turn to.

What we want to do here is to replace the sky in **Figure 5.40**—which you'll recognize as the image with the tree we cut out in chapter 4—with something a bit more interesting (**Figure 5.41**).

FIGURE 5.40

FIGURE 5.41

1. Open the **tree.jpg** file in Photoshop and go to *File > Place Embedded* (or *File > Place* if you're using an earlier version of Photoshop). Navigate to the **new-sky.jpg** file and click OK. Press Enter (PC) or Return (Mac) to confirm the placement. This places the new-sky file at the top of the layer stack above the tree (**Figure 5.42**).

2. Unlock the tree layer by clicking on the padlock attached to that layer (**Figure 5.43**), and then drag the tree layer above the new-sky layer in the layer stack (**Figure 5.44**).

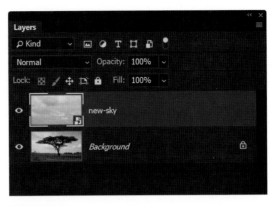

FIGURE 5.42

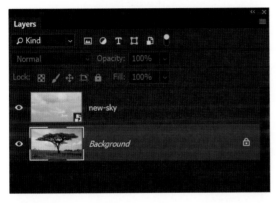

FIGURE 5.43

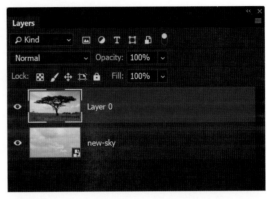

FIGURE 5.44

3. With the tree layer highlighted in the layer stack, double-click to the right of the layer name to bring up the Layer Style properties (**Figure 5.45**). In the Blending Options tab, you'll see the Blend If area toward the bottom of the dialog. The Blend If sliders are a superb and incredibly fast way to blend images together based on their color. In our example, we want to replace the blue sky on the tree layer with the sky on the layer below.

FIGURE 5.45

To do this we don't need to make any selections or use layer masks, we can simply change the Blend If menu from Gray to Blue, and then use the This Layer slider (**Figure 5.46**). When you drag the marker on the far right of the This Layer slider to the left, Photoshop will remove the blue from the layer. As you do this, the sky disappears, revealing the sky on the layer below (**Figure 5.47**).

FIGURE 5.46

FIGURE 5.47

4. If you see areas where the blend looks obvious and the transition is very defined, you can help to blend these areas by holding down the Alt (PC) or Option (Mac) key, clicking on the This Layer slider marker to split it in two, and then moving the two marker halves apart (**Figure 5.48**). When you're satisfied with the blend, click OK.

FIGURE 5.48

There will always be images on which this technique does not work so well, but when it does work, it works great and is super quick. In our example image, even the sky that is visible through the branches has been replaced (**Figure 5.49**).

To see exactly what moving the This Layer slider has done to the tree layer, click the eye icon of the new-sky layer to turn it off. When you do this, you can see all the transparent areas of the tree layer (**Figure 5.50**). We achieved that without making ANY selections!

FIGURE 5.49

FIGURE 5.50

REALISTIC SKIN SMOOTHING

Figure 5.51 is a portrait of actress Sarah Elizabeth Lewis that I took for my ongoing 1940s project. I want to show you a couple of techniques that I used during the retouching process, the first of which is my favorite way to smoothen skin. This is a superb technique that adds realistic skin smoothing, but also maintains the skin texture.

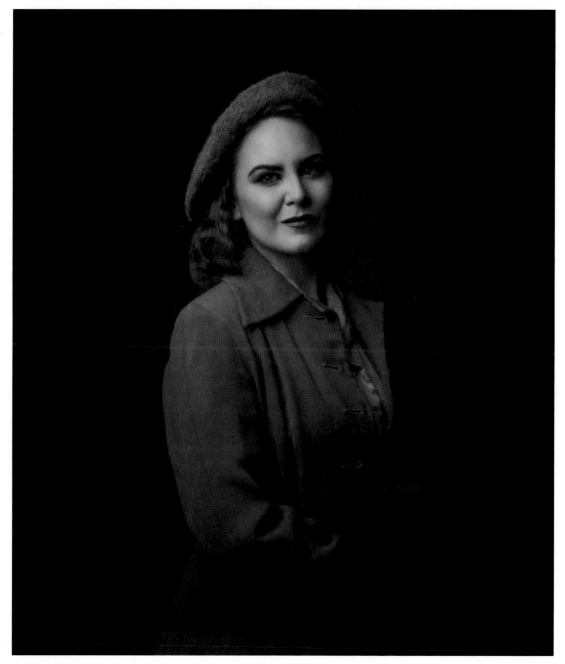

FIGURE 5.51

1. Open the **sarah.tiff** file in Photoshop and create a duplicate layer by pressing Ctrl + J (PC) or Command + J (Mac). Rename the layer smooth skin (**Figure 5.52**). We do this so that the original image is safe, but also so that we can use it to control exactly how smooth we make the skin.

2. With the smooth skin layer selected in the Layers panel, change the blend mode to Vivid Light (**Figure 5.53**). This will create what looks like a very high-contrast version of our picture. Next, go to *Image > Adjustments > Invert* (**Figure 5.54**) or use the keyboard shortcut Ctrl + I (PC) Command + I (Mac).

3. Go to *Filter > Other > High Pass*. For a high-resolution picture, a Radius of 20 Pixels will be perfect (**Figure 5.55**). For a lower-resolution picture, just dial in a lower amount. Click OK.

FIGURE 5.52

FIGURE 5.53

FIGURE 5.54

FIGURE 5.55

4. Next we need to add a small amount of blur, so go to *Filter > Blur > Gaussian Blur,* and for a high-resolution image a Radius of around 3 Pixels is all you need (less for a lower-resolution image) (**Figure 5.56**). Click OK.

Ordinarily, High Pass might be what you'd use for adding contrast to an image or creating an intense sharpening effect; however, we inverted our file so this means the opposite happens (i.e., instead of sharpening the image, High Pass softens or smooths it).

5. The actual smoothing has now been applied, but at this stage our picture doesn't look quite

FIGURE 5.56

right and we've lost the highlights and blacks in the important areas (**Figure 5.57**). The next step is to click on the fx icon at the bottom of the Layers panel and choose Blending Options from the pop-up menu (**Figure 5.58**).

This is another way that we can access the Blending Options, as opposed to double-clicking on the layer like we did in the previous "Replacing Sky Super Fast" section.

FIGURE 5.57

FIGURE 5.58

6. This time, again, we'll use the This Layer slider to make the picture look more natural, while still retaining the smoothness. Hold down the Alt (PC) or Option (Mac) key and click on the black marker on the far-left side of the This Layer slider to split it in two. Drag the right half to around the 0/221 point (**Figure 5.59**).

7. The previous step brought back some of the lighter parts of the image, so now we need to bring back some of the darker parts, particularly around the eyes, nose, and mouth. Hold down the Alt (PC) or Option (Mac) key and click on the white marker on the far-right side of the This Layer slider to split it in two. Drag the left side of the marker to around the 70/255 point (**Figure 5.60**). Click OK.

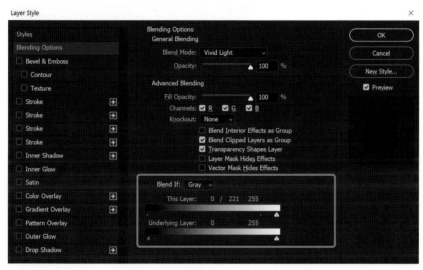

FIGURE 5.59

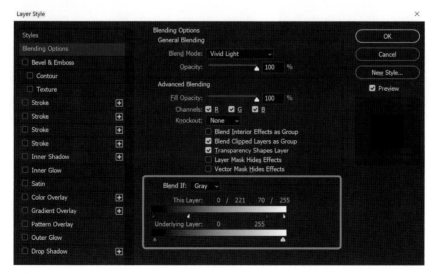

FIGURE 5.60

8. At this stage we've applied smoothing to the entire picture, but we only want it to appear on Sarah's skin. To restrict where the smoothing appears, we'll add a layer mask. This needs to be a black layer mask, so hold down the Alt (PC) or Option (Mac) key and click on the Add Layer Mask icon at the bottom of the Layers panel. With a normal round, soft-edged brush and white foreground color, paint over the face at 100% Opacity to reveal the skin smoothing. If you think the effect is too strong, simply lower the Opacity of the layer (**Figure 5.61**).

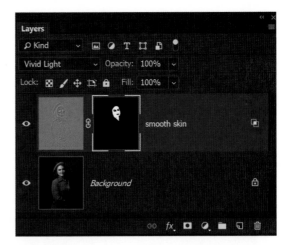

FIGURE 5.61

 TIP *If you can't see where you have painted on the layer mask, press the backslash key. The areas you've painted on are not covered in the red overlay, so if you see red overlay on the skin, simply paint over it with the brush. When you're done, press the backslash key to return to the normal view.*

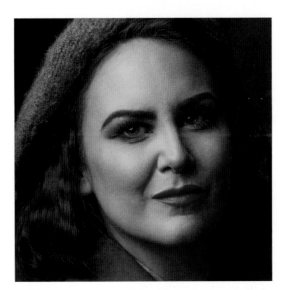

FIGURE 5.62 Before

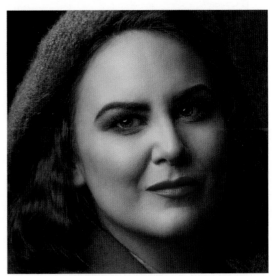

FIGURE 5.63 After

SKIN GLOW

Techniques don't get any simpler than this one for adding a romantic glow to your pictures. This works well for both portraits and landscapes.

1. Create a duplicate of your picture in the Layers panel by pressing Ctrl + J (PC) or Command + J (Mac). Rename this layer **glow** (**Figure 5.64**).

2. Go to *Filter > Blur > Gaussian Blur,* dial in a Radius of around 10 Pixels, and click OK (**Figure 5.65**).

3. Lower the Opacity of the glow layer to around 40%. At this point you could add a layer mask and paint the effect off the eyes; however, I tend to find that at such low settings, I very rarely, if at all, feel the need to do this because there is still enough sharpness.

FIGURE 5.64

FIGURE 5.65

FIGURE 5.66 Before

FIGURE 5.67 After

FIGURE 5.68

COMPOSITING TECHNIQUE

When I first started using Photoshop I created a lot of composite images, blending elements of several pictures together to create one final image. I worked on a series of pictures where I would photograph animals in captivity and then cut them out from their backgrounds and add them into new scenes that resembled their natural habitats. I guess it was my way of setting them free. Actually, writing this makes me want to get back into creating some more composites for this project.

One such image I created of a rhino is a perfect example to use to walk you through two simple techniques that I used to make it look believable that the rhino was part of the natural habitat scene. These techniques involve the Color blend mode and Opacity.

1. Open the **rhino.psd** file in Photoshop. In it you'll see that there is a Background layer (which is itself a composite of elements blended together) and above that the Rhino layer, with the Rhino already cut from its original background (**Figure 5.69**).

FIGURE 5.69

2. Click on the Background layer and create a duplicate by pressing Ctrl + J (PC) or Command + J (Mac). Rename this layer **Color** and drag it to the top of the layer stack (**Figure 5.70**).

3. Click on the Color layer, go to *Filter > Blur > Average*, and click OK. The Average filter looks at the layer and mixes it all together so that we end up with an average color of the scene across the entire layer. Go to *Layer > Create Clipping Mask*, and now the color layer is only visible on the visible parts of the layer directly below, which in this case is the rhino (**Figures 5.71** and **5.72**).

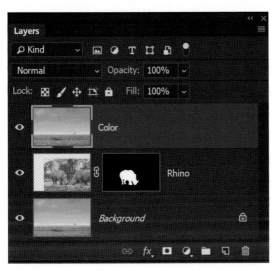

FIGURE 5.70

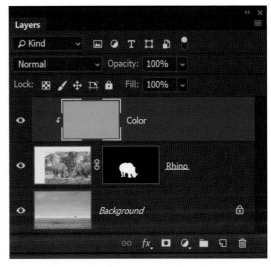

FIGURE 5.71

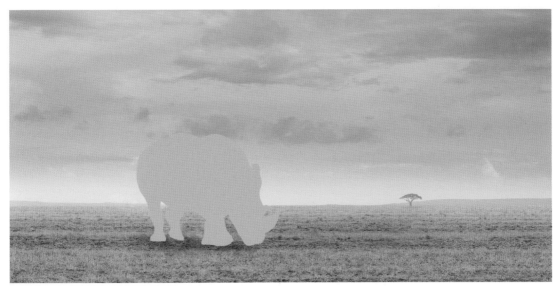

FIGURE 5.72

4. Change the blend mode of the Color layer to Color. This keeps the color of the layer, but also allows us to see the details of the rhino on the layer below. Lower the Opacity of this Color layer to around 20% (**Figure 5.73**).

FIGURE 5.73

As was described in chapter 4, the Color blend modes uses the color from the BLEND layer and the luminosity and detail from the BASE layer. This is why when we use the Color blend mode, we see the color of the BLEND layer (the Color layer) as well as the rhino below (the BASE layer).

Blending with Opacity

Yet again, this is an incredibly simple technique that can make a big difference.

Continuing on with the final rhino image from step 4 in the previous section, click on the Rhino layer and simply lower the Opacity to 90%. Don't go any lower because you will make the rhino (or whatever element you're using this technique on) become too transparent. However, just reducing the opacity of the layer a very small amount definitely helps to blend the rhino into the scene (**Figure 5.74**). Thanks to digital artist Uli Steiger for this little gem.

FIGURE 5.74

WHITEN TEETH-FAST!

When I first started using Photoshop and was buying every magazine I could find to go through all the techniques, I remember seeing several articles showing how to whiten teeth. These techniques would go on for several pages, showing how to select the teeth using the Pen Tool, sample colors, and making all manner of color adjustments. This seemed to take way too long, which is why I love the technique covered in this section.

1. With the **geek.jpg** file open in Photoshop, grab the Lasso Tool (L) and draw out a rough selection around Dave's (fake) teeth (**Figure 5.75**).

2. With the selection in place, we're basically telling Photoshop to ignore everything except for what is within the selection—i.e., the teeth. Click to add a Hue/Saturation Adjustment Layer (**Figure 5.76**) and choose Yellows from the Master drop-down menu (**Figure 5.77**), since we want to remove the yellow from the teeth.

Notice how because we made a selection of the teeth and then added the Hue/Saturation Adjustment, this is represented in the layer mask thumbnail in the Layers panel. The area we selected is white and everything else is black, meaning the area outside of the selection will be ignored when we make adjustments.

FIGURE 5.75

FIGURE 5.77

FIGURE 5.76

3. Now all you need to do is to drag the Lightness slider across to the right to lighten the yellow and brighten the teeth. In this example, I've moved the slider to +60, which has the desired effect (**Figure 5.78**).

FIGURE 5.78

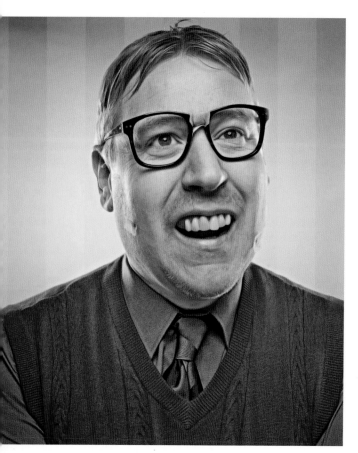

FIGURE 5.79 Before

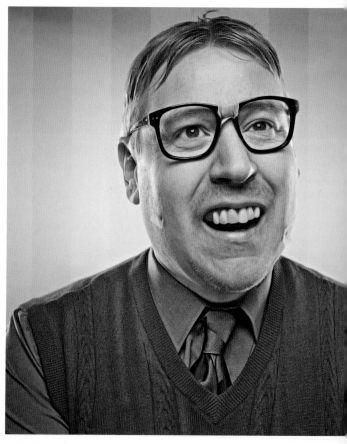

FIGURE 5.80 After

PERFECT LIGHTING CHEAT (KIND OF)

I call this a cheat, but it's actually more of an enhancement to what has already been captured in-camera. I use this technique on pretty much on every portrait and yet again, it's simple but incredibly effective and often results in me getting questions about how I did the lighting for the shoot.

We'll use a portrait of one of my closest friends, Anthony Crothers, as an example (**Figure 5.81**). I explain the lighting style at the time of the photo shoot in a video on my YouTube channel: bit.ly/tptb-anthony.

Here's the simplest technique I use to finesse the lighting on the subject's face:

1. With the **anthony.jpg** file open in Photoshop, duplicate the layer by pressing Ctrl + J (PC) or Command + J (Mac). Rename this layer **lighting**, and then go to *Filter > Convert for Smart Filters* (**Figure 5.82**).

FIGURE 5.81

FIGURE 5.82 The icon in the bottom-right corner of the lighting layer shows it is a Smart Object

2. Go to *Filter > Camera RAW Filter*. In the Camera RAW workspace, grab the Adjustment Brush (**Figure 5.83**) and set the Exposure slider to around +0.10. Leave all other adjustments at their defaults of 0. Put a check mark in the Mask checkbox at the bottom of the Adjustment Brush panel so that you can see where you are adjusting (**Figure 5.84**).

FIGURE 5.83

3. Brush over the face so that it's covered with the red overlay (mask) (**Figure 5.85**). (Your mask overlay may be set to a color other than red. You can change the color by clicking on the little color square next to the Mask checkbox and selecting a new color from the Color Picker.) If the overlay spills onto other areas, turn on Erase and brush over those areas to remove it (**Figure 5.86**).

4. When you feel that the overlay covers the correct area, click on the Mask checkbox to turn it off, adjust the Exposure to around +0.45, and click OK.

That's all there is to it—simple, but effective!

FIGURE 5.84

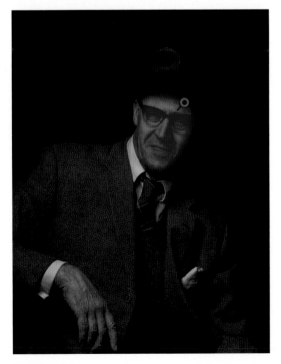

FIGURE 5.85

FIGURE 5.86

FIGURE 5.87 Before

FIGURE 5.88 After

SKIN TEXTURE

Back in chapter 4 I went through a technique for reducing skin shine and I mentioned that I followed that up with a technique for maintaining skin texture. Sometimes when you reduce skin shine on a larger area using the method I covered in chapter 4, the results can look a little flat and smudged, lacking the original texture of the skin. Here is a technique for bringing back the skin texture so that the result is much more realistic:

1. With the **john.jpg** file open in Photoshop, add a new blank layer and rename it **skin shine**.

2. Grab the Healing Brush (J) from the toolbar, and in the options bar at the top of the screen, set Mode to Darken and click on the Make Canvas Sample as Source for Heal icon next to Source (**Figure 5.89**). (The Source options may look slightly different for you, depending on whether you're using the current version of Photoshop, but when you hover over the icon momentarily, a description of its function will appear. Just don't choose the Use Pattern as Source for Heal option.) Finally, set Sample to All Layers.

FIGURE 5.89

3. The area of shiny skin we want to remove is on John's forehead (**Figure 5.90**). As I explained in chapter 4, hold down the Alt (PC) or Option (Mac) key and click to sample any area of non-shiny skin, then use this sample to brush over the shine. Because this is quite a large area, continue to sample areas of non-shiny skin as you work around the shiny patch until it is covered.

4. You can see how the result looks a bit too obvious—the area has a smudged, low-contrast appearance (**Figure 5.91**). To fix this, hold down the Ctrl (PC) or Command (Mac) key and click on the thumbnail of the skin shine layer in the Layers panel. This loads the content of this layer as a selection (**Figure 5.92**).

FIGURE 5.90

FIGURE 5.91

FIGURE 5.92

With this selection now active, click on the Background layer in the Layers panel (**Figure 5.93**) and go to *Layer > New > Layer Via Copy* to put a copy of the selected area of John's forehead onto it's own layer. Rename this layer **skin texture** and drag it to the top of the layer stack (**Figure 5.94**).

FIGURE 5.93

FIGURE 5.94

5. Now we're going to use a filter to show the texture only, so first go to *Filter > Convert for Smart Filters*, and then change the blend mode of the skin texture layer to Overlay. Now go to *Filter > Other > High Pass* and drag the Radius slider down to 0.1 Pixels. All you need to do now is to increase the settings by slowly dragging the slider to the right until the texture in what was the shiny area matches the texture of the surrounding skin as closely as possible. In this case I increased the settings to 3.2 (**Figure 5.95**). When you're satisfied, click OK.

FIGURE 5.95

6. To finish off, lower the Opacity of the skin texture layer to around 60% to allow some of the original to show through.

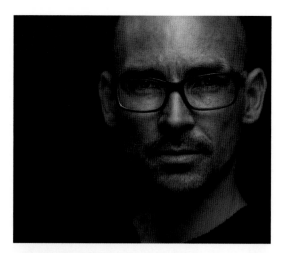

FIGURE 5.96 Before

FIGURE 5.97 After

REDUCING REDNESS IN SKIN

This is my favorite technique for reducing skin reddening. Whether you're working with the natural tone of the skin or a sunburn, this technique works a treat. What I love about it the most, apart from the great results you get with it, is that it uses what is considered to be a basic method to adjust colors.

Figure 5.98 shows a portrait of Rosa that I took for a full-length tutorial covering photography and retouching. The retouching process included removing some red patches from her legs (**Figure 5.99**), and that's what we'll do now.

1. With the **rosa.jpg file** open in Photoshop, zoom into the red area on Rosa's legs. Click to add a Hue/Saturation adjustment layer (**Figure 5.100**).

FIGURE 5.98

FIGURE 5.99

FIGURE 5.100

In **Figure 5.101** we see the properties for the Hue/Saturation Adjustment layer. At the bottom of the Hue/Saturation Properties are two multicolored bars, which are like a stretched-out color wheel. The top bar remains static, but if you drag the Hue slider to the left or right you'll notice that the colors on the lower bar move. This is showing that when you move the Hue slider, the colors in the upper static colored bar (which represent the original colors in the image) are changing to the colors that are directly below them. So for example, in **Figure 5.102** the reds in the picture would change to blue/cyan, greens would change to red, and so on.

FIGURE 5.101 FIGURE 5.102

2. In the Hue/Saturation Properties, change the Master menu to Reds. When you do this you'll notice that four markers appear underneath the colored bars: two outer markers and two inner markers (**Figure 5.103**). These markers represent the range of reds that Photoshop is saying you will alter now that you have selected Reds from the Master menu. The area directly above the two middle markers is the main red you'll be altering, and the two outer markers represent colors on either side of the red that will also be altered.

The question is how do we know that the reds Photoshop is saying we will be altering are the reds on Rosa's legs?

We can check to see what reds will be affected by drastically increasing their saturation to make them stand out. Drag the Saturation slider all the way across to the right to +100 (**Figure 5.104**). The result here is that the area of color in the picture represented above the four markers is highly saturated (**Figure 5.105**).

FIGURE 5.103

FIGURE 5.104

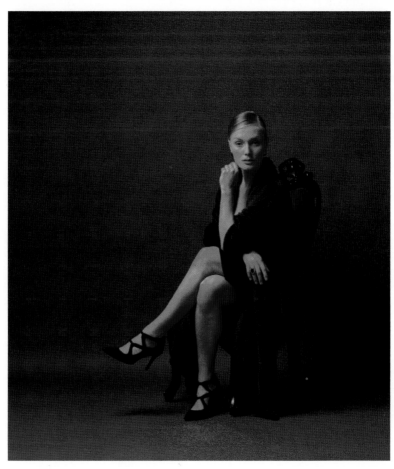

FIGURE 5.105

3. Clearly the range of reds that Photoshop chose when we changed the Master menu to Reds isn't quite where we need it to be. To change it, position your cursor in between the two middle markers underneath the colored bars and drag to the left. As you do this, a different range of colors will be targeted and the area on Rosa's legs that we want to change remains saturated (**Figure 5.106**). This is telling us that the markers are now positioned correctly—the color directly above them is the color we need to change. Are you with me?

There are other areas in the picture that are still saturated but we can deal with those by

FIGURE 5.106

using the layer mask in a moment. Now that we know the markers are correctly positioned we can reduce the Saturation back to its default setting of 0.

4. When it comes to reducing a color in an image, we need to think of the color wheel (**Figure 5.107**). In the simplest terms, the opposite of red is cyan, the opposite of green is magenta, and the opposite of blue is yellow. If we want to reduce the reddening in Rosa's skin, we simply add in the opposite color to cancel it out—i.e., we need to add in more cyan. To do this, drag the Hue slider marker slowly to the right toward cyan, while at the same time watching the reddening on Rosa's legs until it eventually disappears. In my case this meant taking the Hue slider to +43 (**Figure 5.108**).

FIGURE 5.107

FIGURE 5.108

5. We've removed the reddening on Rosa's legs; however, this change in color will also affect other areas of the picture, such as her lips. To correct this, all we need to do is to click on the layer mask attached to the Hue/Saturation adjustment layer, and then go to *Image > Adjustments > Invert* to change it from white to black. This hides the changes we just made behind the black mask (remember, white reveals, black conceals).

Now simply choose a normal round, soft-edged brush with a white foreground color and brush at 100% Opacity over the red area on Rosa's legs so that the Hue/Saturation adjustment is only visible in that area (**Figure 5.110**).

 TIP *To help the change in color blend in you could also click on the layer mask and apply a small amount of Gaussian Blur (2 – 3 pixel radius).*

FIGURE 5.109 Before – reddening

FIGURE 5.110 After – no reddening

COLORIZING LIKE THE MOVIES (CREATIVE CLOUD ONLY)

This technique is a perfect example of taking a "what would happen if...?" approach to using Photoshop and, in this case, Premiere Pro CC as well.

While I was working on this book an update was released across the Creative Cloud for Premiere Pro CC (which is the software I use for editing my videos). This update introduced a function called Color Match, which is different in so many ways from the Match Color command in Photoshop. It not only works different, but the results are way better.

In chapter 2 I explained how I use LUTs (Look Up Tables) to colorize my images; well, this takes it a step further. The idea behind Color Match in Premiere Pro CC is to be able to make video footage from a number of different cameras look similar in the final edit. For example, the main footage for a short video may have been filmed with one camera, such as a Canon, but other angles and B-roll footage may have been filmed with a GoPro or maybe even a mobile phone. Therefore, the ability to make the footage from each camera match (as much as possible) provides much more continuity and creates a better viewing experience.

Sounds great, right? What if we approach this update with the mindset of "What would happen if...?" If it works with moving images, what about still images? For example, what if we could make one of our own pictures match the look of a still from a movie?

Well, let's see...

1. With Premiere Pro CC open, go to *File > Import*. Navigate to a flattened version of the file you are currently working on and also to a still from a film or TV show and click Open. To follow along with this tutorial, import the **peter.jpg** file (which is a photograph from my World War 2 Project) as well as the **film.jpg** file (which is a screen grab from a film trailer on YouTube).

2. Drag the peter.jpg file onto the timeline and then drag the film.jpg file onto the timeline. Position the files so that film.jpg is first and peter.jpg follows (**Figure 5.111**).

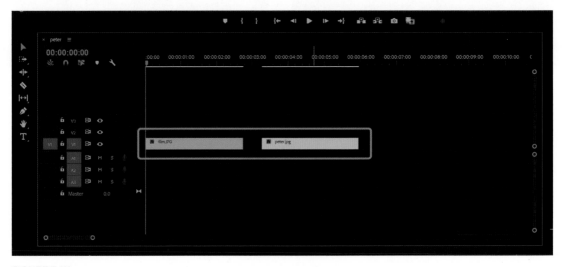

FIGURE 5.111

3. Drag the play head onto the peter.jpg file in the timeline so that it's visible (**Figure 5.112**). Click on Color in the toolbar at the top of the screen, and then click on Comparison View in the panel on the right (**Figure 5.113**).

FIGURE 5.112

FIGURE 5.113

4. Click on Apply Match (**Figure 5.114**), and see how Premiere Pro CC does a great job of looking at the film.jpg file (Reference) and giving our peter.jpg file a very similar coloring (**Figure 5.115**)—all with just one click!

 Of course, we're experimenting here so this isn't perfect. We can adjust the shadow, midtone, and highlight areas to fine-tune the color a bit more, but I think just seeing this is incredibly exciting. And it gets better...

5. Click on the Lumetri Color menu icon at the top of the panel on the right and choose Export .cube from the menu (**Figure 5.116**). Navigate to where you'd like to save the file, name it something like **film**, and click OK (**Figure 5.117**). I saved mine to my Desktop.

FIGURE 5.114

FIGURE 5.115

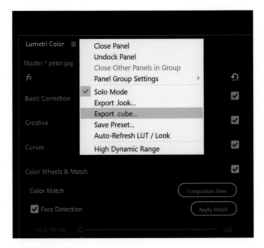

FIGURE 5.116

FIGURE 5.117

Now comes the magic part…

6. In Photoshop, open the **peter.jpg** file and add a Color Lookup adjustment layer (**Figure 5.118**).

7. In the Properties, click on Load 3D LUT in the uppermost drop-down menu (**Figure 5.119**), and then navigate to where you saved the file from Premiere Pro CC. Select the file and click LOAD, and the coloring created from the film.jpg file is now applied to the image of Peter (**Figure 5.120**). Isn't that cool?!

FIGURE 5.118

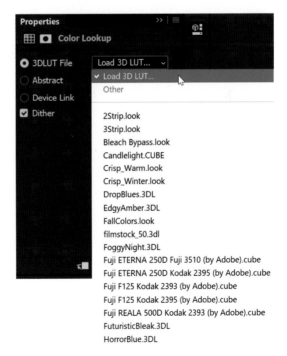

FIGURE 5.119

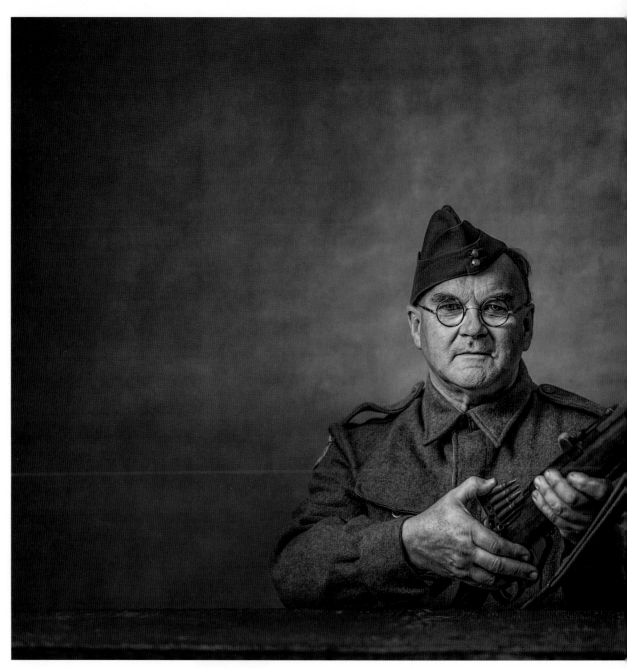

FIGURE 5.120

Of course, it doesn't stop here. We could add more Color Lookup adjustment layers, use Opacity or blend modes, or add any other color adjustments, but it's stuff like this that really excites me and gets me thinking about future possibilities.

At the time of discovering this there is third-party software available that permits you to do something similar, but you'll have pay for most programs. This technique makes use of what you already have!

If you do give this a try I'd love to hear how it goes. Maybe try using it to match the color or tone of other pictures you've seen? Will it work with black-and-white images?

What about using this technique when you're creating composite images? One of the most important things to do when creating composites is to match the coloring and tone of the background scene with that of the person or object being added to the scene. This makes the final image much more believable.

I've already covered a technique earlier in this chapter that I use to match color in composites, and it works great (see the "Compositing Technique" section). But what about using this Look Up Table creation technique in Premiere Pro CC to create a LUT of the background that you can then apply to the person or object being added to the scene in Photoshop? Once you've created the LUT in Premiere Pro and imported it into Photoshop, you could add the Color Lookup adjustment layer, and then create a clipping mask so that the LUT only affects the layer directly below it (i.e., the layer that contains the cutout).

The possibilities you can discover just by experimenting with these techniques are incredibly exciting. And hey, if they work they work and if they don't, well, at least you tried it.

Remember, "what would happen if...?!"

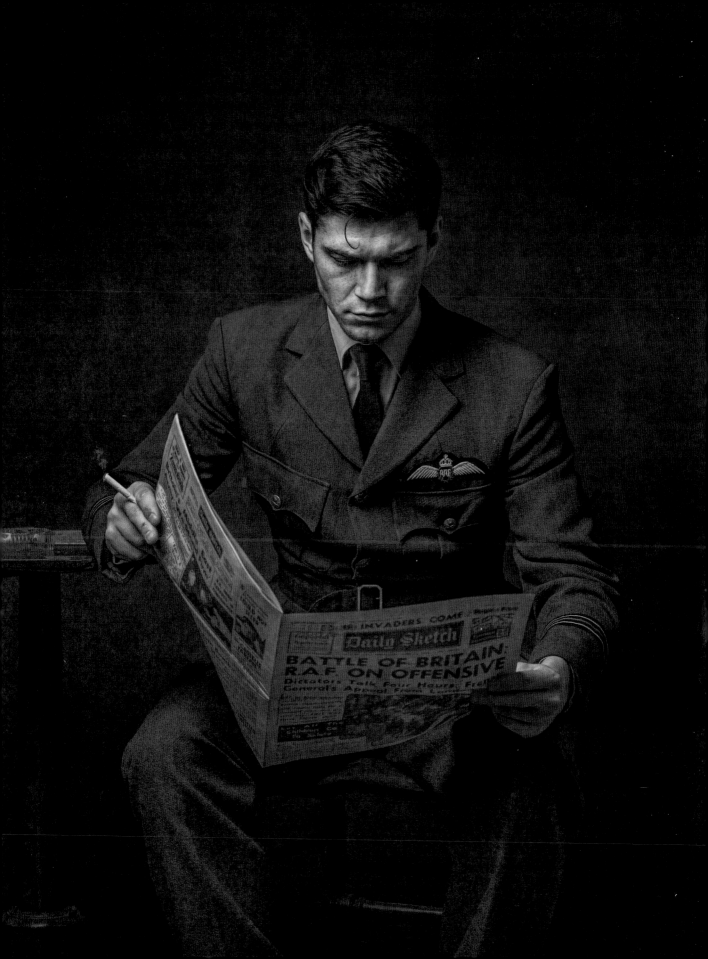

PORTRAIT RETOUCHING WORKFLOW

In this chapter we're going to step things up and go through a complete portrait retouch from start to finish so that we can see how techniques work together to produce a final print-ready picture.

I mentioned in the beginning of this book that I highly recommend you learn a number of techniques that will give you the same or very similar results because there isn't one technique that will work well on every picture. Knowing a number of different techniques means that if one doesn't work well, you can find another in your Photoshop Toolbox that does.

We're going to start in Camera RAW with the RAW file, but if you use Lightroom feel free to start there because the workflow will be pretty much identical. From there we'll take our image file into Photoshop. We'll be working on a photograph of a Royal Air Force Pilot from my on-going 1940s World War 2–themed project. If you're interested in seeing the behind the scenes documentation showing how I did this portrait there's a post on my website at the following URL: www.glyndewis.com/raf-1940/.

While we're on the subject of personal projects, I haven't mentioned them yet, but they're something I highly recommend you do. I honestly believe having personal projects has helped me develop my photography and post-production/retouching skills by keeping me excited and always looking to learn more.

Right, enough of my ramblings, let's get to work…

Download all the files you need to follow along step-by-step at: http://rockynook.com/pstoolbox

CAMERA RAW

1. Starting in Photoshop, go to *File > Open* and navigate to the **06_raf.dng** file. Because this is a RAW file it will open in Camera RAW (**Figure 6.1**).

FIGURE 6.1

2. Let's start off by correcting the white balance in the picture. Select the White Balance Tool (**Figure 6.2**) and click on the gray background. When I did this I clicked just to the side of Lewis's (the model's) head (**Figure 6.3**).

FIGURE 6.2

> **NOTE** *One thing I get asked quite often is whether I have a set pattern of steps that I follow each and every time I retouch a portrait. The simple answer is no, not really. Sure, there's always certain things I do, but when I actually do them depends on the image. I tend to look at the image I have in front of me and whatever jumps out at me is what I do first. Then I stop, look at the image again, and then do whatever it is I'm drawn to next. Does that make sense?*
>
> *The reason I mention this is because the Camera RAW interface, and indeed Lightroom, is arranged in such a way that you could start at the top of a panel and work your way down through the adjustments in order. I just don't choose to work this way, which again reinforces what I said at the beginning of this book: there's no right or wrong way to do something; there are just good and bad results.*

FIGURE 6.3

3. I want to see more detail in the shadow areas, so in the Basic panel, move the Shadows slider to the right all the way to +100. Having done that, I think the image actually needs a little more light overall, so take the Exposure slider to around +0.50, which seems to be enough to me. This increases the highlight areas a bit more than I'd like, so drag the Highlights slider to around −50. Then drag the Blacks slider to around +15 to bring in even more detail in the dark areas (**Figure 6.4**).

FIGURE 6.4

4. We'll add sharpening to the portrait in specific areas later on to create a particular effect, but I almost always add some sharpening when I'm in Camera RAW or Lightroom, so we'll do that now. Click to access the Detail panel and in the Sharpening section, drag the Amount slider to around 40, which is what I tend to use for male portraits (**Figure 6.5**).

5. This sharpens the entire picture, but we only want it to affect Lewis and the table and chair (not the background) because the sharpest area is what the viewer is drawn to. So, just like we covered in chapter 2 on layer masks, we can use the built-in automatic layer masking to restrict where the sharpening is applied.

To do this, hold down the Alt (PC) or Option (Mac) key while moving the Masking slider to around 40 (**Figure 6.6**). We can see from the preview that this is just about right to ensure that the sharpening (shown in white) is not being applied to the background, but is concentrated on Lewis (**Figure 6.7**).

I rarely, if ever, make changes to the Radius and Detail sliders—the default seems to work just fine.

FIGURE 6.5

FIGURE 6.6

FIGURE 6.7

6. Next, go to the Lens Corrections panel and put check marks in the Remove Chromatic Aberration and Enable Profile Corrections checkboxes (**Figure 6.8**). This is something I always do.

I got into the habit of checking the Remove Chromatic Aberration checkbox when I first started using Camera RAW and Lightroom. At the time, I was using lenses that weren't as high quality as what I use now and would regularly see purple fringing in my pictures. I no longer have this issue (not that I have noticed anyway), but I still always choose to turn on the Remove Chromatic Aberration feature.

I don't think there is anything else we need to do to the picture in Camera RAW (or Lightroom), so now we're going to send it over to Photoshop so we can carry on with the retouching.

If we'd made a lot of adjustments up to this point, I'd send the file into Photoshop as a Smart Object. That would mean that if at a later stage we decided that the changes we'd made in Lightroom or Camera RAW weren't quite right, we could just double-click on the layer in Photoshop to send it back into Camera RAW and fine-tune any earlier adjustments.

FIGURE 6.8

However, we haven't done a great deal to this particular portrait, and if we had to repeat the steps it would take very little time, so at this stage my choice is to send the file to Photoshop as just that, a regular file. However, as always, what you choose to do is up to you; there's no right or wrong way.

7. Before sending the file into Photoshop, we need to ensure that some settings are in place so that we carry over the very best file. In Camera RAW, directly beneath the picture you'll see some text that provides information about this particular file (**Figure 6.9**). This includes the color space, bit depth, pixel dimensions, and pixels per inch (ppi).

FIGURE 6.9

We want to be editing in 16 bit, 300ppi, and my preferred color space is Adobe RGB. There is, of course, the ProPhoto RGB, but we'll save discussing that for another time.

At the moment I use Adobe RGB because I often send my images to be printed at a lab and Adobe RGB is the color space used by my lab. Editing in Adobe RGB and sending files to the lab in Adobe RGB means that what I see on the screen is what I will see in print (having calibrated my screen, of course).

If you want to change the settings, simply click on the text below the image, make your changes in the Workflow Options dialog, and click OK (**Figure 6.10**).

FIGURE 6.10

Once you're happy with the settings, click on Open Image in the bottom-right corner of the Camera RAW interface (**Figure 6.11**).

FIGURE 6.11

PHOTOSHOP

1. With the file now open in Photoshop, let's rename the layer. Double-click on the Background layer and name it **RAW Conversion** (as this is the file that we adjusted in Camera RAW) (**Figure 6.12**).

2. If you've read the blog post I mentioned in the introduction to this chapter, you'll have seen in some of the behind the scenes pictures that the canvas background I placed behind Lewis was quite narrow, which is why his arm is close to the edge of the frame in the out-of-camera picture (**Figure 6.13**).

FIGURE 6.12

FIGURE 6.13

We'll use the Crop Tool (**Figure 6.14**) to alter the composition so that Lewis is a bit more central in the picture. Select the Crop Tool and turn on the Content-Aware Fill option in the options bar at the top of screen (**Figure 6.15**).

NOTE *If you are using an earlier version of Photoshop, you may see a Content-Aware checkbox instead of the icon. For the same results, simply tick this checkbox.*

FIGURE 6.14

FIGURE 6.15

3. Click on the middle crop handle on the right side of the image and drag outward until Lewis's head is in the middle of the grid (**Figure 6.16**), then press Enter (PC) or Return (Mac).

FIGURE 6.16

Photoshop will use Content-Aware Fill to fill in the right side of the image by using information in the picture (**Figure 6.17**).

NOTE *If you ever have difficulties with Content-Aware where it includes areas that you don't want, then be sure to check out the "Content-Aware Fill Trick" in chapter 5.*

4. Before we move away from the Crop Tool, I want to reduce the amount of space above Lewis's head and crop out the very bottom of the picture where we can see the end of the canvas backdrop. With the Crop Tool selected, drag the top-middle handle downward (**Figure 6.18**). We don't need to crop much, but in my opinion, there was too much empty space above his head. Drag the bottom-middle handle up just a touch, and then press Enter (PC) or Return (Mac) to accept the crop.

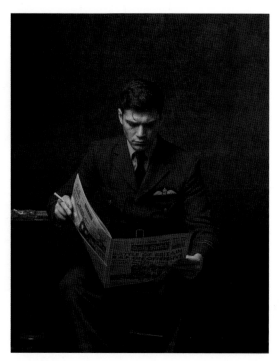

FIGURE 6.17

NOTE *You might be wondering why we didn't crop down from the top at the same time we extended the image to the right. The reason I chose not to was to give Content-Aware as much of the background as possible to use to fill in the empty pixels on the right. If we cropped the top at the same time, we could have restricted the area Content-Aware had to play with.*

FIGURE 6.18

5. With the composition sorted, let's move on to Lewis. When we zoom in and look at his face, we can see that there is a particularly bright area on his nose. We can reduce this with the Healing Brush. Click on the Add New Layer icon at the bottom of the Layers panel to add a new blank layer to the top of the layer stack, and name this layer **Shiny Nose** (**Figure 6.19**).

Choose the Healing Brush (J) from the toolbar (**Figure 6.20**), and in the options at the top of the screen, set the Mode to Darken and ensure that Sample is set to All Layers (**Figure 6.21**).

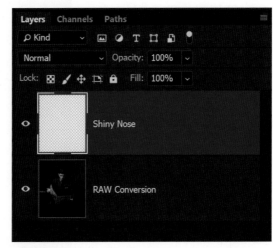

FIGURE 6.19

FIGURE 6.20

FIGURE 6.21

> **NOTE** *Setting the blend mode to Darken means that when we use the Healing Brush, it will only darken those areas of the picture that are brighter than the area we use as our sample (source).*
>
> *We set Sample to All Layers because we are working on a new layer that has no pixels within it. Using All Layers means that the Healing Brush will be able to look down through the layer stack to find pixels to use as a sample area.*

Zoom in close to Lewis's face and then press the left or right square-bracket key to adjust the size of the Healing Brush so that it is just slightly wider than the bright patch on his nose (**Figure 6.22**).

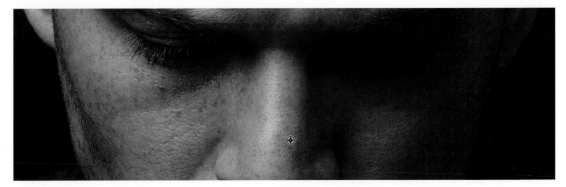

FIGURE 6.22

Hold down the Alt (PC) or Option (Mac) key and click to sample an area of skin to the right of the shiny patch on Lewis's nose. Then use the Healing Brush to cover over the bright area, taking care not to brush over areas of non-shiny skin (**Figure 6.23**).

6. Now that we have removed the bright area of skin it looks a little too obvious, so to help it blend in and make it look much more realistic, lower the Opacity of the Shiny Nose layer to around 50% (ish) (**Figures 6.24** and **6.25**).

7. Now we're going to do little bit of dodging and burning to add more depth and dimension to Lewis's face. Go to *Layer > New > Layer* (**Figure 6.26**). In the New Layer dialog, name this layer **Dodge & Burn**, choose Soft Light from the Mode menu, and put a check mark in the Fill with Soft-Light-neutral color (50% gray) checkbox (**Figure 6.27**). Click OK.

FIGURE 6.23

FIGURE 6.24

FIGURE 6.25

FIGURE 6.26

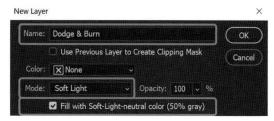

FIGURE 6.27

8. Choose the Dodge Tool from the toolbar (**Figure 6.28**), and in the options at the top of the screen, set the Range to Midtones, the Exposure to anywhere between 5% and 10%, and turn on the Minimize Clipping in Shadows and Highlights and Prevent Hue from Shifting icon (shown as Protect Tones in earlier versions of Photoshop) (**Figure 6.29**).

Use the Dodge Tool to paint over areas of Lewis's face to enhance them, just as I covered in the "Dodging and Burning" section in chapter 4. Hold down the Alt (PC) or Option (Mac) key to activate the Burn Tool with the same settings, and darken the areas on either side of the highlights and the other darker areas of the image.

This is all very dependant on personal taste, but you can see the areas I enhanced in **Figure 6.30**.

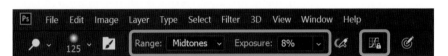

FIGURE 6.29

FIGURE 6.28

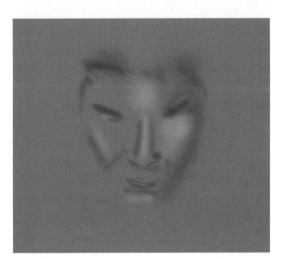

FIGURE 6.30 The 50% grey Dodge & Burn layer showing the areas I brightened and darkened.

NOTE *To see the gray layer, hold down the Alt (PC) or Option (Mac) key and click on the eye icon of the Dodge & Burn layer. To return to normal view, simply do the same again.*

9. At this stage of the retouching I like to dive in and use the Topaz Clarity plugin. Plugins are an additional expense, so this isn't an essential part of the workflow and it may be a step that you don't want to include. However, I like to use this plugin because it gives me much more control over the contrast and clarity that I add to pictures; rather than a single slider, it has a number of sliders to control the intensity.

When using the Topaz Clarity plugin, the first thing we need to do is create a merged layer at the top of the layer stack. With the top layer active you can use the keyboard shortcut Shift + Alt + Ctrl + E (PC) or Shift + Option + Command + E (Mac). Rename this layer **contrast** (**Figure 6.31**).

10. Now we'll use the Topaz Clarity plugin to start adding contrast to the fine details of the image, which seems to bring the picture to life. I must admit that despite being familiar with Photoshop, I've never been able to replicate exactly the look that Topaz Clarity gives an image, which is why I turn to it time and time again.

Go to *Filter > Topaz Labs > Topaz Clarity* (**Figure 6.32**). In the controls on the right side of the screen, increase Micro Contrast to 0.25, Low Contrast to 0.13, and Medium Contrast to 0.05, and then click OK (**Figure 6.33**). The amounts you dial in here are completely dependant on your personal taste.

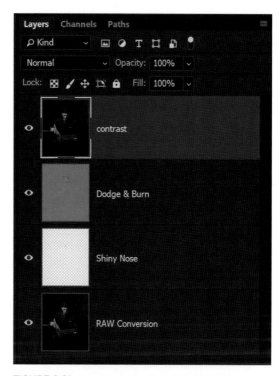

FIGURE 6.31

FIGURE 6.32

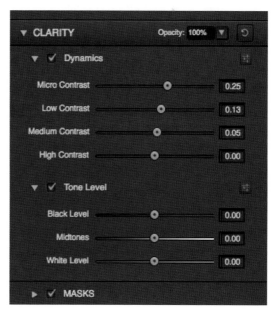

FIGURE 6.33

11. The next step is to color grade the picture to give it the right mood. We'll do this using Color Lookup adjustment layers, which are without doubt my favorite way to colorize my pictures.

 Click on the Color Lookup icon in the Adjustments panel to add a Color Lookup adjustment layer (**Figure 6.34**).

FIGURE 6.34

12. In the Color Lookup Properties, select TensionGreen.3DL from the top menu labeled 3DLUT File (**Figure 6.35**). In the Layers panel, lower the Opacity of this adjustment layer to 30%.

13. Add a second Color Lookup adjustment layer and select EdgyAmber.3DL from the 3DLUT File menu (**Figure 6.36**). In the Layers panel, lower the Opacity of this adjustment layer to 30%.

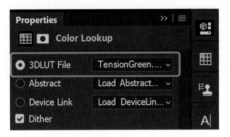

FIGURE 6.35

FIGURE 6.36

14. Add a third Color Lookup adjustment layer and select FoggyNight.3DL from the 3DLUT File menu (**Figure 6.37**). In the Layers panel, lower the Opacity of this adjustment layer to 30%.

15. When colorizing images we don't have to just use the Color Lookup adjustment layers; we can use other adjustment layers too. Press D to set the foreground and background colors in the toolbar to their defaults of black and white, and then click to add a Gradient Map adjustment layer (**Figure 6.38**).

FIGURE 6.37

FIGURE 6.38

This is a great way to create black-and-white images, but in this case, we're going to use it to reduce the saturation in our picture. In the Layers panel change the Opacity of the Gradient Map adjustment layer to 30% (**Figure 6.39**).

NOTE *Sometimes you might find that despite setting your foreground and background colors to black and white, when you click to add the Gradient Map, Photoshop applies a red gradient or even a white-to-black gradient that makes your picture look infrared. If this happens, don't worry; all you need to do is go to the Gradient Map Properties and choose the third gradient from the left in the top row, which is Black to White (**Figure 6.40**)*

FIGURE 6.39

FIGURE 6.40

16. Add another Color Lookup adjustment layer and select DropBlues.3DL from the 3DLUT File menu (**Figure 6.41**). In the Layers panel, lower the Opacity of this adjustment layer to 40%.

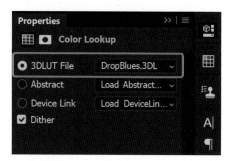

FIGURE 6.41

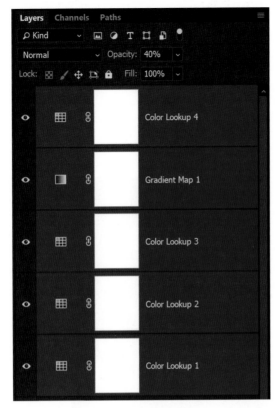

FIGURE 6.42

17. To keep the layers organized, let's put all of the adjustment layers that we've added to colorize the picture into a group. With the uppermost layer active, hold down the Shift key and click on the Color Lookup 1 layer so that all of the adjustment layers are selected (**Figure 6.42**). Then go to *Layer > New > Group from Layers* (**Figure 6.43**). Name the group **colorize** and click OK.

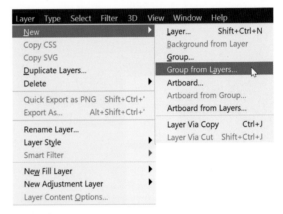

FIGURE 6.43

18. Now that we've colorized the picture, I'm really loving the feel that it gives to the image, but I'm not so keen on how it's affecting both the skin tones and the original blue of the RAF uniform. We'll reduce the colorizing effect on these areas, but we can't simply reduce the opacity of the group because this will reduce the colorizing everywhere in the picture. Instead we'll use a layer mask.

19. Click to add a white layer mask (**Figure 6.44**) to the colorize group (**Figure 6.45**). Press D on the keyboard to make sure the foreground and background colors are still at their defaults of black and white. (Press X to swap the foreground and background colors.)

FIGURE 6.44

FIGURE 6.45

Choose a normal round brush from the toolbar and set the Hardness to around 30% and the size to 200 px (**Figure 6.46**). (If the brush was completely soft, it would spill over into other areas of the picture as we paint over the edges of Lewis's face and uniform). In the options bar at the top of the screen set the Opacity and Flow of the brush to 100% (**Figure 6.47**).

FIGURE 6.46

FIGURE 6.47

With the layer mask active in the Layers panel (you can see there's a frame around it **Figure 6.48**) use the black brush to paint over Lewis's skin and uniform, hiding the colorizing effect from those areas (**Figure 6.49**).

 TIP *To look for any areas you may have missed when painting on the layer mask, press the backslash key. The areas covered by the layer mask are indicated with a red overlay.*

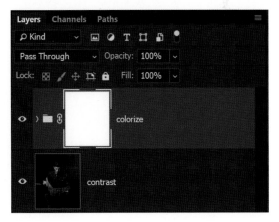

FIGURE 6.48

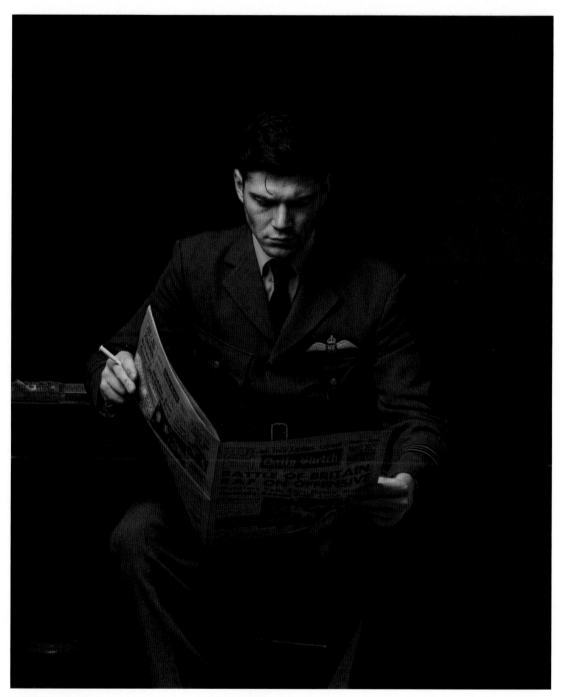

FIGURE 6.49

20. Once you have removed the colorizing from Lewis's skin and uniform, double-click on the layer mask in the Layers panel to open the Properties and reduce the Density slider to 40% (**Figure 6.50**). Doing this reduces the density of the black on the layer mask so that we can control exactly how much of the colorizing effect shows through.

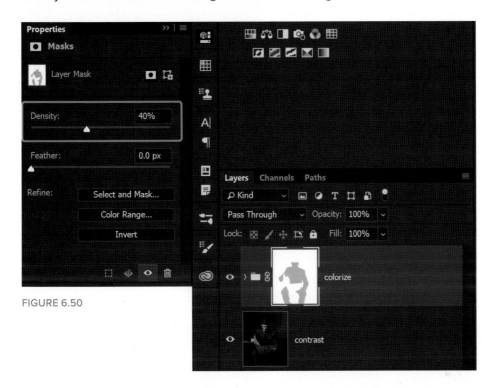

FIGURE 6.50

NOTE *Using a black brush at 100% and then adjusting the Density slider ensures that the color is removed evenly. You may think of simply painting with a black brush at a reduced opacity, but the danger with that is you can very easily go over areas more than once, which would result in the effect being reduced more in some areas than others.*

21. Now let's now add some smoke to the cigarette. We'll do this using a brush we made in chapter 3, "Brushes."

Add a new layer to the top of the layer stack by clicking on the Add New Layer icon at the bottom of the Layers panel. Name this layer **smoke** (**Figure 6.51**).

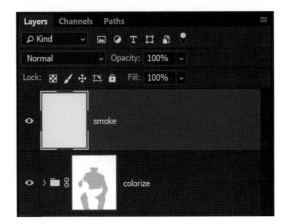

FIGURE 6.51

Press D to set the foreground and background colors to their defaults of black and white. We need the foreground color to be white, so press X to switch the foreground and background colors if you need to. Choose the smoke brush from the Brush Preset picker, resize it to around 800 px (or whatever you feel looks right), place it at the tip of the cigarette, and click down (**Figure 6.52**).

22. This looks great, but for added realism we need to add some ash to the tip of the cigarette, which we can do with another brush.

FIGURE 6.52

Add a new layer to the top of the layer stack and name it **ash**. Set the foreground color to black in the toolbar and with the Brush Tool selected, go to the Brush Preset picker at the top of the screen and choose the Spatter 59 Pixels brush (**Figure 6.53**).

23. Click on the Brush Settings icon in the options bar to enter the Brush Settings panel, and in the Brush Tip Shape section, increase the spacing to 55% (**Figure 6.54**).

Click on Shape Dynamics and increase the Angle Jitter to 100% (**Figure 6.55**). Then click on Color Dynamics and set the Foreground/Background Jitter to 50% (**Figure 6.56**).

FIGURE 6.53

FIGURE 6.54

FIGURE 6.55

FIGURE 6.56

24. Zoom in close to the tip of the cigarette, use the left and right square-bracket keys to adjust the size of the brush, and apply a few brushstrokes to look like ash (**Figure 6.57**).

25. To darken the ash, add a Levels adjustment layer and click on the clipping mask icon at the bottom of the Properties panel to add a clipping mask (**Figure 6.58**). This means that any adjustments we make will only affect the layer directly beneath (i.e., the ash). With the clipping mask in place, move the midtones slider to the right to 0.80.

FIGURE 6.57

FIGURE 6.58

26. Again, let's put the layers into a group to keep them tidy. With the uppermost layer (the Levels adjustment layer) selected, hold down the Shift key and click on the smoke layer so that all three of the cigarette layers are selected. Then go to *Layer > New > Group from Layers*, name the group **cigarette**, and click OK.

The next few steps are completely optional, but this is a look I tend to add to pretty much all of my portraits to some degree or another. I call it my painterly or waxy effect, mainly because I can think of no other way to describe it.

27. Add a merged layer to the top of the layer stack by using the keyboard shortcut Shift + Ctrl + Alt + E (PC) or Shift + Option + Command + E (Mac) and rename this layer **look**. Press Ctrl + J (PC) or Command + J (Mac) to duplicate this layer and rename the duplicate layer **sharpness**. Turn off the sharpness layer by clicking on its eye icon, and then click on the look layer to select it (**Figure 6.59**).

28. Go to *Filter > Noise > Reduce Noise* (**Figure 6.60**), and in the Reduce Noise dialog, increase the Strength slider to around 8 and set all other sliders to 0 (**Figure 6.61**). (You can click and hold in the large preview window to see a "before" version of the image, and then release to see the preview of the image with the effect applied). Click OK.

When applying this effect, you can immediately see the waxy look it gives to the skin; however, you'll also notice that using the filter in this way reduces sharpness in areas where you might not want it to. The next step resolves this issue.

FIGURE 6.59

FIGURE 6.60

FIGURE 6.61

29. Click on the sharpness layer and click the eye icon to make the layer active. Go to *Filter > Other > High Pass*, and in the High Pass filter settings dial in a Radius of 1 Pixel (**Figure 6.62**). Click OK.

30. Change the blend mode of the sharpness layer to Hard Light to remove the gray (**Figure 6.63**), and you'll notice that sharpness has returned to prominent areas of the picture. (Click on the eye icon to turn the layer on and off to see the before and after.)

> **NOTE** *Using Hard Light to remove the gray from the sharpness layer ensures that the sharpening is contrasty and noticeable. Try other blend modes like Overlay and Soft Light to see how the results differ.*

FIGURE 6.62

After I apply this painterly, waxy effect I always add more contrast to the entire picture. Of course, Photoshop being Photoshop, there are seemingly countless ways to add contrast, but one technique I like to use involves the Unsharp Mask Filter. I find that using this method allows me to add considerable contrast without noticeable halos or color shift, which can occur with other techniques.

31. Add a merged layer to the top of the layer stack by pressing Shift + Ctrl + Alt + E (PC) or Shift + Command + Option + E (Mac) and rename this layer **usm contrast** (for Unsharp Mask Contrast) (**Figure 6.64**).

FIGURE 6.63

FIGURE 6.64

32. Go to *Filter > Sharpen > Unsharp Mask* (**Figure 6.65**), and in the Unsharp Mask dialog, set Amount to around 16% and use the exact same for Radius. Keep Threshold set to 0 (**Figure 6.66**). (Again, click and hold in the preview window to see a before and after.) Click OK.

> **NOTE** *For best results when using the Unsharp Mask filter to add contrast, be sure that you use the same number for Amount and Radius. I always set Threshold to 0.*

I use contrast and light to give my portraits added depth and dimension, making it feel almost like they are coming toward the viewer. This becomes very evident when the pictures are printed, especially on metal.

33. Add another merged layer to the top of the layer stack by pressing Shift + Ctrl + Alt + E (PC) or Shift +

FIGURE 6.65

Command + Option + E (Mac) and rename this layer **usm face**. Then go to *Filter > Sharpen > Unsharp Mask*, and this time in the Unsharp Mask dialog, reduce the previous Amount and Radius by half (so this time Amount 8% and Radius 8 Pixels) (**Figure 6.67**). Click OK.

FIGURE 6.66

FIGURE 6.67

34. Add a black layer mask to the usm face layer by holding down the Alt (PC) or Option (Mac) key and clicking on the Add Layer Mask icon at the bottom of the Layers panel (**Figure 6.68**). This hides the result of the previously applied Unsharp Mask filter so that we can use a white brush to reveal it on only the face.

Use a normal round, soft-edged brush with a white foreground color and 100% Opacity to paint over the face, revealing the Unsharp Mask contrast in this area only (**Figure 6.69**).

At this stage, I'd probably walk away from the screen for a while to give my eyes a break. Getting into the habit of doing this is one of the best pieces of advice I received a few

FIGURE 6.68

years back from my friend Matt Kloskowski. It enables you to look at your picture with fresh eyes and immediately see what needs to be done. This break can be as short as five minutes; just be sure to take a break.

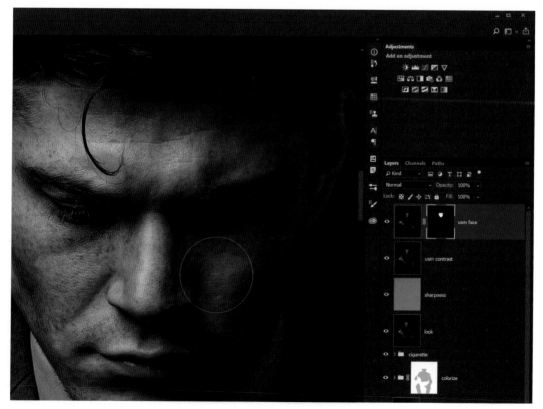

FIGURE 6.69

35. The last thing to do involves diving into the Camera RAW filter. Add one final merged layer to the top of the layer stack and rename this layer **Camera RAW**. Then go *Filter > Camera RAW Filter* (**Figure 6.70**).

36. What I do in Camera RAW is again very much down to personal taste, but to give you an idea, I'll walk you through what I did in the original retouch of this image:

- Increase the Temperature to +5 to warm up the image a little (**Figure 6.71**).

- Add a Radial Filter and position it to include the top half of Lewis, then reduce the Exposure slider to −0.40 (**Figure 6.72**).

- Use an Adjustment Brush to add a little light to the face and draw the viewers' attention toward it. Choose the Adjustment Brush Tool (K), set the Exposure to around +0.20, and brush over Lewis's face. Turn on the Mask checkbox so you can clearly see where you have brushed (**Figure 6.73**).

- Once you've painted over the face, uncheck the Mask checkbox, and then dial in the Exposure until you're happy with the amount of light on Lewis's face. For me, +20 was enough.

FIGURE 6.70

FIGURE 6.71

FIGURE 6.72

FIGURE 6.73

- Finally, select the Hand Tool (**Figure 6.74**), click on the Basic tab, and reduce the saturation of the picture by dragging the Saturation slider to around –20 (**Figure 6.75**). Then click OK to return to the main Photoshop workspace.

Camera Raw (06_raf.psd)

FIGURE 6.74

FIGURE 6.75

FIGURE 6.76 Out-of-camera RAW file

FIGURE 6.77 Final retouched image

So there you go: a complete workflow taking a picture from it's RAW "out of camera" state to print-ready, making use of layer masks, brushes, and blend modes along the way.

As I said at the beginning of this book, Photoshop is a HUGE piece of software, which in some ways is a great thing because it offers so much, but in other ways can make it a little daunting. However, no matter what is currently in Photoshop and what is introduced in the future, at the core are layer masks, brushes, and blend modes.

I truly believe that with a little bit of understanding and a willingness to experiment and approach Photoshop with a mindset of "What would happen if...?!?", the sky literally is the limit.

Keep enjoying the process,
Glyn